DRAWING STEP-BY-STEP

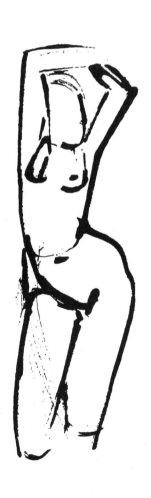

DRAWING STEP-BY-STEP

GERHARD GOLLWITZER

Sterling Publishing Co., Inc.
New York

Drawings not otherwise acknowledged are the work of students.

10 9 8 7 6 5 4 3 2 1

Published in 2002 by Sterling Publishing Company, Inc.
387 Park Avenue South, New York, N.Y. 10016
First published in a hardcover edition under the title
Express Yourself in Drawing © 1960 by Sterling Publishing Co., Inc.
Originally published in Germany under the title *Zeichenschule fur
Begabte Leute* ©1959 by Otto Maier Verlag
Distributed in Canada by Sterling Publishing
c/o Canadian Manda Group, One Atlantic Avenue, Suite 105
Toronto, Ontario, Canada M6K 3E7
Distributed in Great Britain and Europe by Cassell PLC
Wellington House, 125 Strand, London WC2R 0BB, England
Distributed in Australia by Capricorn Link (Australia) Pty. Ltd.
P.O. Box 704, Windsor, NSW 2756 Australia
Manufactured in the United States of America

Sterling ISBN 0-8069-8901-7

CONTENTS

BEFORE YOU BEGIN

> *Draw, Antonio; draw, Antonio; draw and
> lose no time! ... Take courage, Andreas, trust
> in me! You will find joy enough!*
> —Michelangelo, *on the margin of his
> pupils' drawings*

Five hundred years ago you, my young friend, might have
been an apprentice in the guild of Saint Luke. Entering the
guild at the age of 12 or 14, you would have ground colors,
primed panels or hewn stone, and you would have been sent
out to fetch fresh rolls for the masters' lunch. Between times
you would have drawn, constantly imitating your elders.
Gradually, without quite realizing it, you would have be-
come a master of your craft in your own right.

A hundred years ago you might have studied at an
academy. There you would have begun by drawing from
plaster casts of antique sculpture, directed and corrected by
a professor.

Today you read this book with the intention of learn-
ing to draw. Can a book—without personal guidance—replace
the master or the professor? Can it substitute for what you
would have learned formerly in the workshop or at the acad-
emy? It can only try, and you have to try even harder if you
are working with the book alone.

Five hundred years ago it did not matter much in whose
workshop you studied. There existed a "style of the time"

which prevailed all over, for despite the diversity of personalities, all artists had the same end in view. Today you find yourself in the midst of a jungle of opinions, directions and methods. They contradict and even fight each other!

Should you learn to draw at all? What does it mean to draw "correctly"? Should you follow what you see in nature or should you invent abstract designs? Wherever you turn you hear another battlecry: "Find your own subjective expression for your feelings!" . . . "Train yourself to look at things objectively!" So it echoes from all sides. One school claims to cultivate in you what another seeks to destroy!

Dare we in such times hand you a how-to-do-it book?

Can you dare to trust in this book alone?

The most convincing proof that *I* believe it is worthwhile is that this book exists. Otherwise I would never have written it. This book is not a discussion about art. It is simply a book to help you learn to draw. It is a workbook, and as you work, you will learn and understand where your goal lies. Many roads lead to Rome, but unless you actually *take* one of them, you will never get there! If you hesitate, sit with your hands in your lap, engage in mere talk about art, you will get nowhere. No book can ever replace a good live teacher, but a book can help you at all times, whereas the teacher is with you only at lesson time.

WHAT THIS BOOK AIMS TO DO

In Japan the master of the art of archery, far from trying to awaken the artist prematurely in his pupil, considers it his primary task to teach him sovereign control of all technicalities.

—Herrigel

I shall try to compensate for the absence of personal guidance by breaking up the subject into clear-cut divisions, so that you will advance easily, step-by-step, through a series of clearly posed problems. What may seem contradictory at first will resolve itself during your work.

The illustrations throughout the book are only examples and suggestions. Don't take them as models or patterns, for they are signposts, not resting places. Most of them are the work of students. I purposely refrained from choosing pictures by contemporary artists which might too easily lead to imitating, for you are supposed to find your own way. However, many different methods of drawing are illustrated, and you can learn something from each if you will remember that this is a book of drawing, not of art. And it is not supposed to be a book of easy recipes!

Art is something innate which exists and grows within each of us, of itself. Craft, however, is something you can learn. You can learn the language of forms, how to play with forms, and the many techniques which constitute the rules of this game.

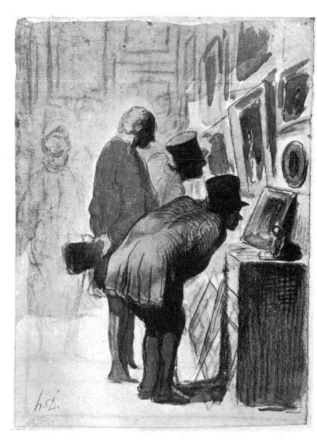

"In a Picture Gallery" by Honoré Daumier, chalk with wash and water color.

A fine drawing grows and develops. It starts from the big, over-all forms and proceeds down to the details, but it is complete at all times, regardless of its state of finish!

What Herrigel said about learning the art of archery applies equally to learning to draw. According to the Japanese master of archery, you must practice without self-conscious purpose. The more intent you are on hitting the target with your arrows, the less you will succeed in learning, and the farther away the target will appear! Why think that

the arrow will miss unless you concentrate on it? Why not wait patiently and see how the arrow flies?

It is true, however, that teaching yourself demands much self-discipline. Instead of having a teacher to help and correct you, you will have to look over your own shoulder and do the job yourself. "Alter the format," you may say. "Work larger." Or, "Draw smaller.". . ."Change your technique; take a hard pencil and go into details.". . ."Stop now, or you'll ruin your drawing by overdoing it.". . ."Now execute your drawing again in fine lines.". . ."Leave this problem alone. You've had enough of plants. Now draw people.". . ."You are becoming too objective. Play around on the paper with your brush! Get up and move around. Breathe deeply. You are getting stiff."

Such hints as these, which you will have to give yourself, are distributed all through the book.

Of course, the artist in any field must strive always to represent his own true nature. Each drawing should be completely and purely his own expression. However, that doesn't mean that you have to worry about safeguarding your individuality and originality. Nor does it mean that you must avoid study and hard work in order to preserve your precious personality and individuality. Every artist must learn everything he can regarding his craft, for as Hesse wrote, "To learn what can be learned is not a handicap but a help and an enrichment in the development of individuality."

Matisse put it another way: *"N'ayez pas peur d'être banal. Si vous avez une originalité, elle sortira bien!"* "Don't be afraid of being banal. If you have originality, it will come out."

"But how about soul and expression?" you may ask. "Technique is dry, but art should be an expression of feeling!" The answer is that creative art consists of forming and shaping, not merely setting forth inner sensations. Everybody

is capable of expression—in movement, handwriting, voice, etc. But our concern here is to transmute expression into lasting form. Of dabbling and dilettantism this world is full enough!

Balzac expressed it this way: "To muse, to dream, to conceive beautiful works is delightful . . . But then comes the creation, the production, the upbringing of the child. To tame the mad chaos of life and let it rise again through one's work to new life that will speak to all human beings, that is the work of the artist. His hands have to act as the indefatigable servants of his fantasy. The artist must work in a tight space like the miner in the rubble of his shaft. He has to fight down all his difficulties, one after another, just as the enamored knight of the fairy tale has to fight the sorcerer in his constantly changing disguises, until he wins his princess."

You know only what you learn. When an adult is asked to multiply 3 by 5 quickly and, without thinking, answers 15, he does not remember how much time and how many calculations were needed for this answer when he was a child. It is the same with drawing. You have to learn one thing after another, and at first you will have to make many calculations that you will never think of again later on.

When the painter, Menzel, was an old man, a publisher went to him with a request for a book title design. Menzel sat down to work immediately, and after a quarter of an hour the design was done. Both were content with the work, and the publisher asked for the price.

"One hundred thaler!"

"But isn't that a little steep?" the publisher asked. "One hundred thaler for a short quarter-hour's work?"

Menzel looked at his visitor angrily and replied, "Young friend, in order to be able to produce this little picture in 15 minutes, I spent 70 years of my life learning!"

DRAWING MEDIA

When the painter Degas was trying to write poetry and complained to the poet Mallarmé that he had difficulty finishing a poem, although he was not lacking in fine thoughts, Mallarmé replied, "Dear Degas, poems are not made out of thoughts but of words."

PAPER

Drawing starts with the choice of paper, not with the first line. There is smooth paper and rough, sized paper and absorbent, thick paper and thin—more different sorts of paper than you can imagine. You should try to collect paper suitable for drawing wherever you can—everything from paper napkins to fine handmade paper. Try out these different papers, playing around on them with different materials. Not every paper is suitable for every material. Then too, sometimes you may like smooth paper over which your pen can glide easily, while at other times you may prefer the slight resistance offered by rough paper.

You will need three different basic types of paper:

1. Cheap paper that you can use up without restraint. This might be cheap stationery, or newsprint (the paper that is used for newspapers, available in pads), or the backs of rolls of wallpaper.

2. A sketch book in pocket size.

3. Good drawing paper in various weights, in sheets, rolls or pads. Drawing paper is usually glaring white, but you can also purchase off-white sheets as well as India-tinted. A beautiful paper with fine texture for chalk and reed pen is Ingres paper, which is available in many tints.

In the beginning use your "waste" paper and thin drawing paper. It doesn't matter what size you use, but it is better to work on a large scale than on too small a scale.

For support, use a wooden board or a composition board (masonite) or a strong cardboard. Fasten the paper to the board with thumbtacks (drawing pins) or clips. Your paper should lie flat and smooth, and for that reason, never roll it unnecessarily. The struggle for success is laborious enough without complicating it by using wobbly and wavy paper! However, you can smooth out rolled-up paper by putting it on a table with the curled side up and then pulling it down, with even pressure, over the edge of the table.

Larger drawings require paper that is stretched over a wooden or composition board, or over a stretcher—a frame made of wood. In order to stretch the paper tight, first wet it with a sponge, wetting from the edges towards the center. This will cause the paper to swell and expand, and while it is wet fasten it down with adhesive or architects' tape. Then as it dries it will shrink and become tightly stretched.

For smaller drawings, seat yourself before a table with the support resting on your knees and leaning against the table; or simply hold it free. You can also put the support on a table and raise the top edge a little by placing a book under it. For larger tasks it is advisable to stand up, putting your paper and support on an easel. If you have no easel, you will have to use a table, but standing up will give you enough distance from the paper so that you will have room to move.

DRAWING MATERIALS

Still more varied than the paper are the materials for drawing. The principal materials are pencil, chalk and charcoal, pen and brush.

The pencil is a delicate tool; it doesn't give too much depth. Pencils come in all grades of hardness, but to begin with, use a medium-soft pencil. (For your finished drawings, later on, you should always use the very finest quality pencil available.) The strength of the line will depend on the paper you use. The more granular the paper, the darker the pencil will write. On the other hand, the smoother it is, the greyer the line. The paper must have enough texture for a good pencil line and enough firmness so as not to allow indentation.

Predecessor of today's pencil is the almost-forgotten silverpoint. It consists of a small, thin piece of silver inserted into a stylus. (A stylus is a holder into which lead or graphite can be inserted and then used as a pencil. It is very handy because it is always ready for use without sharpening.) Silverpoint drawings require a special preparation of the paper, say with a heavy coat of white tempera (distemper). The silverpoint produces only medium-grey, silvery, delicate lines which, once drawn, cannot be erased. Albrecht Dürer, at the age of 13, drew his famous self-portrait with a silverpoint!

Chalk and charcoal are soft tools, especially suitable for working with light and shadow. The chalk line is velvety black and, even in the heaviest layers, has a matte or dull appearance. It is coarser than the pencil line and without its metallic shimmer. Chalk can be used in a wooden stylus or without the holder in angular pieces. The pieces are preferable as you can break them into short pieces 1 or 2 inches long; then you can draw with flat sides to produce tone, as well as with the pointed end. You can do the same thing with brown or red chalks, which are also obtainable

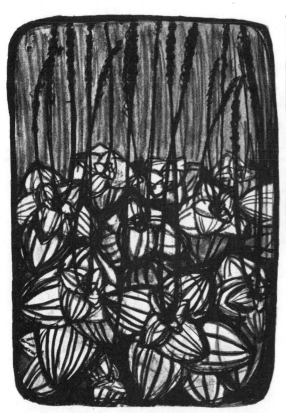

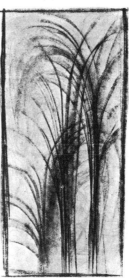

(Above, left) Chalk, "Plantains in a Meadow". (Above, right) Chalk, "Rising Forms". (Below) Graphite drawing, "A School of Fish".

plain or in a holder. You have to be careful when working with chalk, as it smudges easily, but the smudging itself can be useful when you do it on purpose. You can rub chalk with your finger or with a kneaded chalk eraser. Or you can make a little roll of blotting paper and roughen it with sandpaper, and obtain broad tones by holding it at a slant as you rub.

Charcoal is only useful for a large drawing or a preliminary drawing, in which case it is blown off and wiped off with a soft cloth or a brush to leave only slight traces. Charcoal is very sensitive; it lies on the paper like dust and demands a light hand; it does not stick. If you draw too much over the same spot, especially with pressure, the paper becomes "dead" and does not take the charcoal. It produces only grey, no depth. Chalk and charcoal call for textured, fibrous paper to which the fine granules can adhere, such as Ingres paper or the back of brown packing paper.

Finished drawings of soft pencil, chalk and charcoal must be treated by spraying with a fixative to protect them from smudging. You can buy it prepared, or make your own by adding 20 grams of crushed resin or 5% white shellac to one quart of alcohol. Let it stand for two days, turning the bottle upside down occasionally. With an atomizer or spray gun, spray the fixative carefully over the paper from a distance of about 20 inches. Small puddles or even drops cause ugly stains, so practice first by spraying a little into the air. Be careful where it lands, however, as it is sticky stuff. It's a good idea to keep the bottle or spray gun well filled, as an almost empty bottle is harder to spray with because the fixative has to be sucked up from the bottom.

You can draw with many different kinds of pens, and you should have an assortment of them: a fine, pointed drawing pen, an old-fashioned writing pen (pen-holder and point)., and a reed pen. The reed pen is wonderful to work with. It absorbs a good deal of ink and therefore produces

lines of all gradations—deep black lines when first dipped into the ink, then gradually lighter and greyer lines. You can buy a reed pen or make your own if you can find the right kind of reed. Take a length of reed with a node at one end and cut it just short of the node at the other end. Bevel that end with a sharp knife and clean off its marrow. Then snip off at a slight angle, resting the pen on a firm support, and carefully split the middle. To hold the ink in the reed, insert a small strip of tin bent into the shape of an S. You can make a quill pen the same way. Both have to be sharpened frequently.

For studies, especially sketch book studies, a fountain

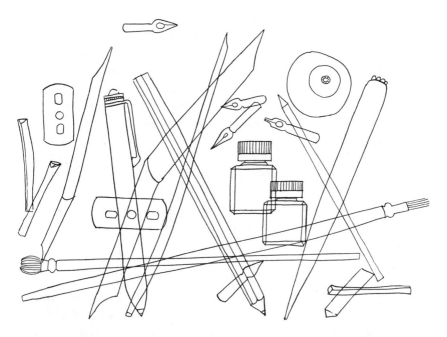

These are the most important materials, but don't let all these different tools worry you. You won't find them confusing in practice!

pen is suitable. Even the ball-point pen—which takes all character out of handwriting—is especially useful for practicing. You can handle it like a pencil and draw in all directions, forward and backward, without its getting stuck and spluttering ink as a pen would.

Inks range from the more thickly flowing ones which are not soluble in water to the thinner ones which are. The most beautiful gradations of grey can be achieved with India ink, and the best kind of India ink is the kind you buy in long, hard pieces and make yourself. You have to prepare it in a small porcelain dish with a little water and lots of patience, and always use it freshly made.

You draw with the same kind of brushes that are used for oil painting: round and flat brushes, in hair or bristle, in many different sizes. Be sure to buy good brushes. When wet, a round brush must not split, nor a flat brush spread out, but they must retain a pointed or flat tip, respectively. The tips should never be pressed down and you should never leave them in a glass of water. Wash them after each use, dry and put away. The best, most flexible brushes of goat hair come from China and Japan, but you have to be quite an advanced draughtsman to use them well, and to their best advantage. Held loosely between the fingers and constantly twirled, they create wonderful effects, producing the finest line or the broadest tone with the slightest pressure.

For your brush drawings choose strong paper, either smooth or textured, with as little sizing as possible. The less sizing it contains the more color it will absorb and the more fullness and depth of tone will result.

If you use a lot of water, as you must for washes or water colors, the paper will buckle and therefore should be tacked down. Another hint: If you, like the Chinese, choose a very absorbent paper such as Japan paper, a high quality tissue

paper, your tones become definite immediately, and you can no longer work into them with washes.

The final tool on the list is an eraser, to remove unsuccessful parts of a drawing. The common pencil eraser is adequate as long as it is flexible, soft and clean. If you rub it on rough wood or sandpaper or pare it with a knife before using, you will prevent ugly spots. Otherwise you will have to use a knife or fine sandpaper to remove the spots made by the eraser!

To erase chalk and charcoal it is best to use plasticine at first. Dab, do not wipe with it. After that you can remove the remains with the regular eraser. Pen drawings can be corrected with a typewriter eraser or with a sharp penknife or razor blade, but beware of holes! Go over the spot or erasure once more with a regular soft eraser and then smooth it with your fingernail. But try to use any eraser as little as possible!

Before you can start a drawing you must choose the medium you intend to use. A carpenter cannot begin to design a cabinet until he visualizes the final result, and he must know what kind of wood he is going to use and how it is to be finished. The poet has to be sure of his language, the actor of his body and his voice. Likewise you have to be familiar with your materials.

Materials and techniques are not only the means of drawing. They are the realities! A line does not exist as such —there is only a line drawn with a pen, or a line drawn with chalk, or a line drawn with a brush. Nor is there a "drawing ground" *per se*—only smooth or rough paper, in this or that shape, on which to draw.

But the media play their part. They contain impulses which want to be thought of and have to be worked with: the paper speaks; the brush speaks; your imagination is stimulated! Unfortunately our eyes have been numbed and spoiled for this sensitive language through too much photography

Without drawing anything in particular, test your materials for their specific, inherent qualities, as shown here for a steel pen.

of art and too many poor reproductions which equalize everything. Unfortunately our machine-made paper is too clean and sterile. It does not "sing" as Japan paper or handmade paper does. That is why I advised you to collect paper. The bare paper itself should inspire something in you.

EXERCISES IN ACTING-OUT ART

Enjoy the true being,
The serious play behold.
No living thing is one,
But always manifold.
— Goethe

Drawing begins long before the first line. It begins with the right posture and the right attitude to your work and the materials. Your hand as well as your whole body must be relaxed. You must learn to see the surface of the paper as a whole, to conquer and master it. How can you arrive at this free and relaxed state? There are many ways, but these exercises in "serious play", strange as they may sound at first, have proven especially successful. You may laugh at yourself —and at me!—all you want while practicing them, but be prepared for unbelievably effective and lasting results!

Put out some fresh rectangular sheets of paper and a pencil or ball-point pen on the table. Then stand in the middle of the room, quietly, with your arms hanging down and your feet next to each other. If possible have the window open. Stand there and wait until you get a feeling of yourself as a column in the air, supported by the air; until you become conscious of your breathing going through you. Think of a slim birch tree or a reed. Then start to swing slightly, backward and forward. Exhale very slowly by pronouncing a long F or S with your lips half closed, or by humming M.

Now exhale completely and wait until your breath—of itself—flows into you again. You must feel it sucked in from deep inside you without your volition. Enjoy it! Remain in this state for a moment, relishing the sensation of relaxed tension. And then exhale very slowly. Now let your body begin to describe circles. Swing your whole body without bending your hips or knees, with your feet as the center of the circles.

"But why should I do that?" you may ask. "I want to learn how to draw, not how to breathe!"

True. But drawing is not a matter concerning only your fingers. It concerns your whole being. You must experience what you want to draw with all your senses. Do try it, even though it may seem strange to you!

Now change from circles to squares, taking care that your breathing continues uninterrupted. Hum a long M. While breathing in, slowly let your arms rise up from your sides. Don't lift them with muscle power, but simply with your breathing! The feeling of becoming light and loose should express itself in this arm-lifting. The movement must begin in back, between your shoulders. When your arms are up, draw large squares in the air. Now, if you are doing these exercises correctly, you will feel like yawning. Do it heartily!

At this point, walk with collected strength toward the paper which is waiting on the table or easel and, still standing, with outstretched arm inscribe on the rectangular format of the paper a flowing inner circle. Follow the circle around several times. Notice how the surface starts to talk! Now begin a vaguely checkered pattern. Letting your line run and flow, draw from the edge toward the center, then down . . . long verticals, short horizontals . . . again move up . . . without ever taking your pencil off the paper. You are not supposed to draw a checkerboard pattern. In fact, you are not yet supposed to "draw" at all, but just to divide space with lines. Next try a trellis of cross-lines, some wide and some

narrow. Hold your pencil or ball-point lightly but firmly, never stiffly or rigidly.

Begin the second exercise as before, but place your feet further apart and swing back and forth from left to right. With every change of direction, exhale forcefully with a PF sound which drives you back in the other direction. This PF sound should be casual though hearty, as if you were making fun of something—this exercise, for example.

"This is really too funny. I always thought one drew with a pencil, not with one's lungs!"

(When you have gotten over your astonishment, give this a thought: Isn't it true that almost everything we do nowadays is specialized? We use our head only; or we use only our hands. We have almost forgotten that the body as a whole is our best means of creation. Walking, facial expressions, voice—all are part of the constant process of formation and creation.)

Next increase your sideways movement by spreading out your arms. Keep your arms straight and feel in your back what you are doing. You are both demonstrating and feeling the meaning of "horizontal". Between your arms your torso

is vertically straight, a contrast to the horizontal position of your arms. Now draw what you have done! Draw many horizontal lines, and a few vertical ones, inside a quadrangle.

Repeat the exercise, this time with a different aim. With your feet together swing from front to back, back and forth. Now let your arms describe many verticals, with a horizontal now and then. Try to draw this, too.

Begin the next exercise in the same way as the others, but let your body as well as your hands and arms describe various forms and rectangular movements. Then draw these with horizontal and vertical lines, first very evenly, later with fewer verticals and more horizontals, or vice versa. Interpret the format and sense whether it stretches broadly or towers high. Cut these new formats out of paper and place them on a dark background. At this point, you should realize at a glance that this one is meant to be upright, that one to be sideward.

Now think of diagonals! Start out by describing large squares in the air. Then, from below, push diagonally into space. Follow up with all kinds of oblique directions. The motions are not important in themselves, but they serve to make you experience space more consciously. Draw lines inside of square frames to illustrate your diagonal motions.

Now for circles. First experience circles physically by acting them out with both arms sideways and then with your arms in front. Remember always to use your breathing, not your muscles, to lift and move your arms; and to channel your breathing with the humming M or the P or PF or F sounds through half-open lips. Go to your paper and draw large circles and small, inside squares and rectangles.

LEARNING THE LANGUAGE OF MEDIA

The best way to begin to learn the possibilities of chalk, pen and brush is through play-exercise. Draw and compare nets of fine pen lines and others composed of broader chalk strokes. Now add tone to some of the squares of the net. For your chalk drawing you do this by using the chalk held lengthwise, or with your finger. Chalks can also be "washed" with a wet brush. For your pen drawing use the pen itself or try a brush. Alternate the sizes of your paper and try working with different tones—white on grey, for instance, or white on black.

You are not really "drawing" yet, eager though you may

be. Have patience! All this play will save you many problems later on, and will lead you into the realm of drawing more quickly than you realize.

After these exercises, which are intended to make you relaxed and free, you are ready for some concentration and discipline. All your further work—like life itself—will move between those two poles, between passivity and action, looseness and tension, license and discipline, fantasy and craftsmanship, inhaling and exhaling. Repeat the previous exercises but be more exact, stricter. Plan the intervals between the lines more consciously and more evenly, and draw the lines straighter and in parallels.

Here are some exercises of a more controlled nature:

Draw a large letter with flowing, continuous curves, placing it artistically on the paper. Intensify it by retracing or

circumscribing parallel lines. Invent monograms and draw them.

Draw an evenly curved S by joining two half-circles. This curve has little tension; both sides are balanced. Now give tension to the curve by describing an S in the air over your drawing again and again until you feel the urge to give the S a different shape—be it more elongated or more rounded—and then give the curve a different stress by moving the apex inward or outward.

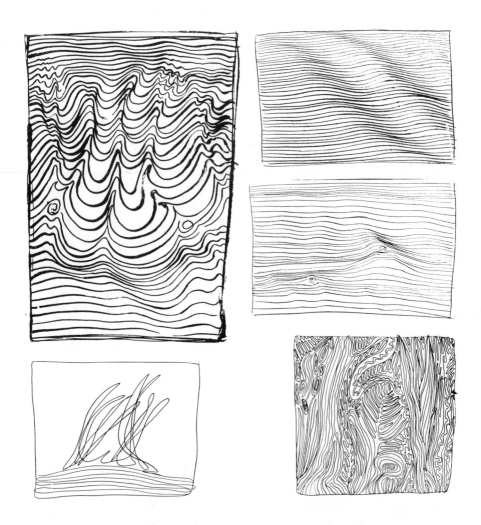

Try to imagine certain rhythms inspired, perhaps, by music. Or try to visualize forms inspired by nature, such as a broadly expanding landscape with poplars, a gull flying through an evening sky of billowing clouds, a school of fish passing, a shepherd resting. But remember that you are just seeking ideas. Don't try to draw birds and fish and shepherds

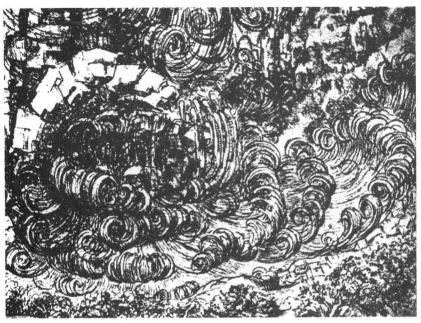

(Above) Chalk, Leonardo da Vinci.

but translate into lines the graceful flight of the gull, the swift passing of the fish, the restfulness of the shepherd.

Imagine, for example, the surface of the sea and move your body as you draw. Talk aloud as you work to force yourself to concentrate on the mental and physical image: "Now the water is calm, unruffled, horizontal . . . Now a light breeze is causing little waves . . . the wind gets stronger and whips the sea . . . big waves rise and break . . . the wind slowly ceases . . . again all becomes quiet and smooth."

Drawing like this means making things happen on paper, but they happen *through you*. You can do it! Don't try to force it and it will come. Just evoke what is already inherent in the plain paper—and in you!

THE UNDERSTANDING OF UNITY

Quanta bellezza al cor per gli occhi!
How much beauty the heart perceives
through the eyes.

—Leonardo

Turning to nature, go out-of-doors and take a good look at various kinds of trees. Look at them and enact them with your body. Imagine that your feet are the roots, your legs and torso the trunk. Lift your arms and hands up alongside your body until they are above your head, then spread them out and move them in circles through the air, like Daphne who was turned into a tree.

See how different the fir and spruce are from beech and oak. Bolt upright are their trunks, horizontal their branches. The birch tree bends its wavering head, and its leaves rustle and shimmer. The large branches of the weeping willow reach out, but its small branches droop dejectedly. See how jagged the apple tree is from too much pruning.

Try to draw these trees at home, not from nature. Standing up, draw with both hands, in chalk, on large sheets of paper or on a blackboard. Draw courageously and in large scale. Use up lots of your cheap drawing paper for such exercises! You will be rewarded later. Draw many different kinds of trees on one sheet to learn from their contrasts. Con-

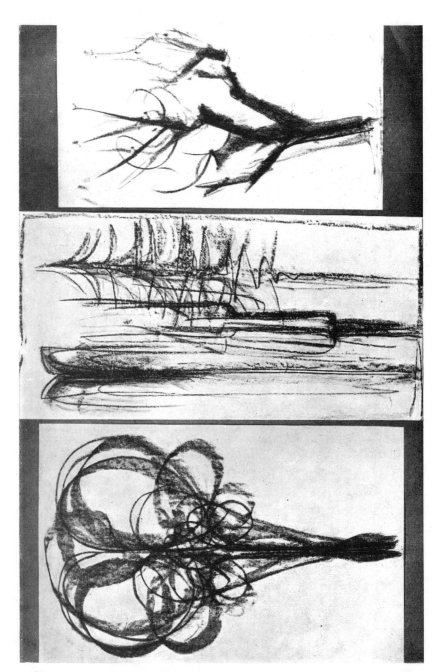

centrate on their movement and rhythm instead of on botanical details.

Try the same exercise with flowers and plants, aiming for contrasts. For instance, draw a plant with large leaves between thin graceful blades of grass; or surrounded by clover with its small round leaves. Again, forget the botanical details. Understand the forms and draw them at home.

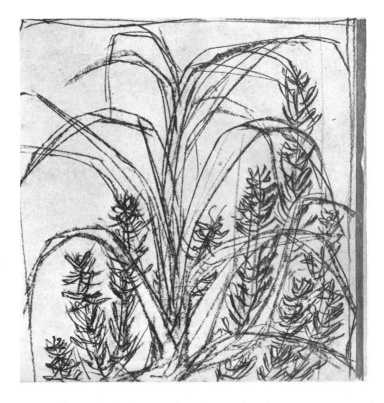

Draw snail shells, or heads, or books, or your easel—anything that catches your fancy—trying to see everything as a unity. That takes practice and more practice. But the time will come when you will be able to see and draw the most

complicated and detailed formation as a unity, instead of stutteringly adding one detail to the next. For the whole is more than the sum of its parts. A tree is more than the combined total of trunk, branches and leaves.

GETTING THE FEELING OF PROPORTION

Take a sheet of paper and draw several objects next to each other in very simple form: a two-story building, a dog-

house, a poplar, a man, a mouse. Undoubtedly you drew them with due regard to their proportions or relative size—the relation of one to another.

Now look around and try to measure exact proportions with your eyes. Starting with height and length, compare the different parts of a tree with each other, and one kind of tree with another kind. Compare the stem and bowl of a goblet; the forehead, nose, mouth, and jaw of a face. Always compare the parts with each other as well as with the whole.

You can help your visual estimate by "aiming", i.e., by holding a pencil vertically at arm's length and sighting against it. Move your thumb up and down for comparison of dimensions.

As simply as possible, draw a tree next to a house; a table top with a plate on it; a face and the back of a head. Now compare the masses—in your drawings, the planes. Try to get the feeling of dimension and mass into your blood so that you know and feel instinctively how the parts relate to each other and intensify each other.

Look around you for various examples of contrasts such as:

<div align="center">

quiet-lying vs. vertical-projecting:

a lake with a poplar alongside

slanting vs. vertical: a beech tree among fir trees

round-full vs. thin-linear: cumulus clouds and stratospheric

round vs. square: a round vase on a table

simple vs. complex: a plain vase full of wild flowers

thick vs. thin: a watering can and its spout and handle

wavering vs. firm: trees in a storm next to a telegraph pole

</div>

Draw such contrasts from your imagination.

Try the same thing with abstract forms. Draw a frame on a sheet of paper in which to contain your efforts. Draw many vertical lines with one slanting line among them; or many thin horizontals below with a big vertical bar superimposed; or draw one big circle with the brush and place many little circles and dots around and in it.

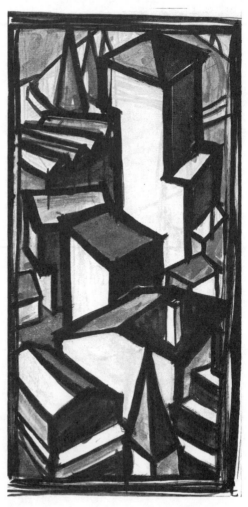

SUBSTANCE IN SPACE

> *At the beginning there was space, the disquieting invention of the Almighty.*
>
> —Beckmann

Here is another game to help you learn the feeling of space. Take a number of boxes of varying sizes and shapes—or better still, a child's set of building blocks—and set them up as children do to form castles, bridges, stations, and churches.

View your construction from all angles, paying particular attention to the spaces you have created between the buildings. Let your eyes wander around it, seeing it as if you were a miniature person promenading through the streets and alleys of the block city. Get the sensation of solids, of substance in space. Then take your pencil or pen and create the city from your imagination—not the boxes, but the room which they occupy and the space they enclose. Draw horizontal lines first to establish the foundation and then erect the cubes, starting from the ground up, in a simple view seen from the side and slightly above. Here lies a village green; there a narrow alley turns a corner; beyond it rises a tower. Draw the parts that you don't see as well as those you do, but try to draw with freshness and freedom. It is not beauty you are after, but the creation and organization of space and the "feeling" of intersections.

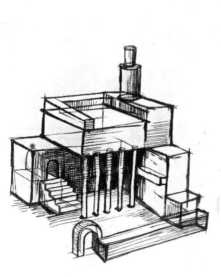

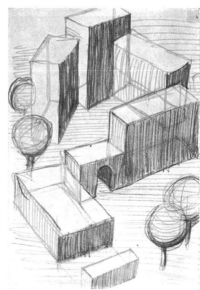

Alternate between building and drawing. Try to imagine the expanse of your buildings in terms of height, width and depth. Then copy what you have constructed—not the boxes but what they represent in terms of space. When you are finished, accentuate the effect by cross-hatching. Don't simply cover the surfaces, but try to show through your hatching that the ground is flat, the buildings rise up, the wall curves round. Three directions for your hatching lines —horizontal, vertical and diagonal—will express all the necessary planes.

It is not the illusion of space you are after, but conscious understanding of three-dimensional matter which will lead you to new visual discoveries. The object of this particular exercise is not to lead you into the art form known as "cubism" but to give you the *feeling* of cubes. Nor is it supposed to be a short-cut device to enable you to reproduce three-dimensional objects more easily on a two-dimensional

surface. Never think about perspective; just make graphically clear what your eyes perceive.

Whenever you walk, take the opportunity to use your eyes as an artist. Walk through the street with wide-open eyes, walk around columns, around the trees in a forest, down the nave of a church, and get the feeling of space and volume through all your senses. Feel with your eyes, your shoulders, your whole body.

Take every opportunity to play with pencil and paper. Fill squares with cubic forms, with boxes, bars, cylinders, balls, cones. Just for fun, place two match boxes together in all possible combinations and draw them. Then push out the inside of the match boxes and you will have further variations to draw.

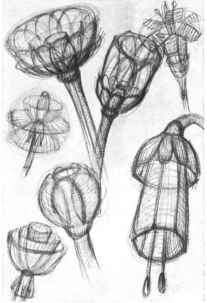

Now draw trees in this "cubic" manner, simply as general forms. Draw fir trees as cones, bushes as balls, poplars as cylinders. Draw flowers with their blossoms closed, or opening up on their slim cylindrical stems. Don't use hatching to indicate light and shade, but make your lines follow the form and create the form. Soon you will begin to see and become familiar with the various cubic forms in the visual world, with examples of this shape or that in nature where none appeared to you before—without especially looking for them.

THE SURFACE

Nothing is wholly inside or wholly outside,
for what is inside relates to the outside.

—Goethe

Every time you admire the sheen of satin or the soft texture of velvet, or observe the plumage of a parakeet, the bark of a tree or the smooth, tight skin of an apple, you are studying that most "superficial" subject, the structure of surfaces.

For a very interesting and illustrative experiment, divide a piece of good drawing paper into squares of about 2 inches. Using a pen (but not a ball-point), fill in one square after another in as many different ways as possible. Try parallels, little crosses, dots, hooks, winding lines, zig-zag lines; make some lighter and some darker, some thicker and some thinner. Then ask yourself about each one, "What kind of surface material could this represent?" Try this exercise over again using a pencil, and then use chalk.

Have you ever really studied a thin crystal goblet—so dainty and fragile and yet so hard—sparkling with reflected lights? Try to look at such a glass with keen eyes, and then compare it with a tumbler made of thicker glass; a wine bottle, mysteriously green; or a cut-glass vase on whose surface the light, which plays so freely on smooth glass, is directed into grooves.

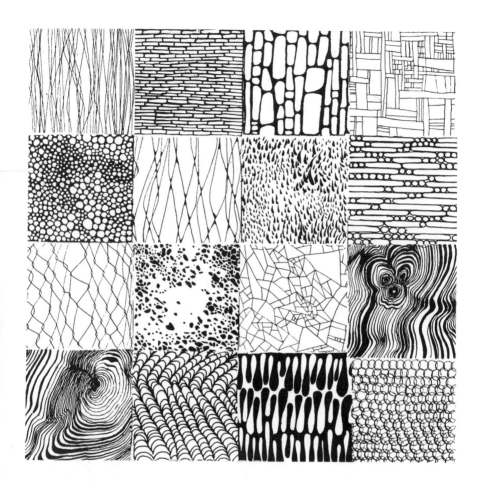

Use your sense of touch to add to what you can learn through your eyes. Feel things with the tips of your fingers and the palm of your hand. Touch the bark of trees and explore the differences between the rough torn bark of fir trees and the tight, tough bark of a beech.

Take a piece of burned out wood from a dead fire and observe the wealth of wrinkles, bubbles and cracks. What a structure to stimulate your imagination!

Compare the skin of various people—the soft, petal-smooth skin of a child with the leathery skin of an old farmer or sailor.

Observe sand dunes, hair, pavement, the surface of your papers.

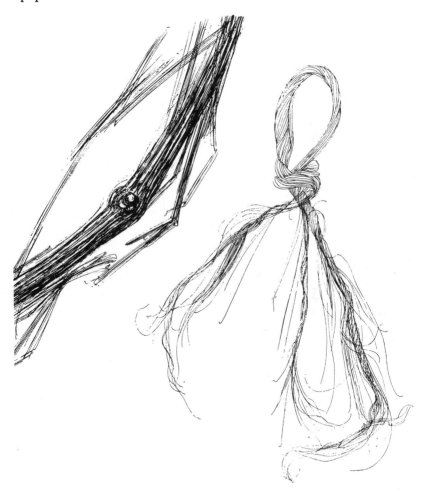

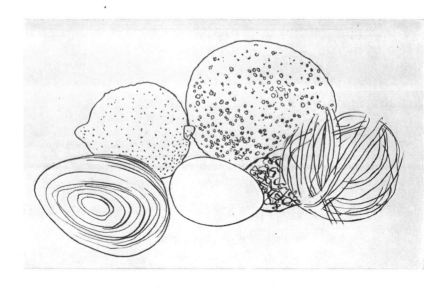

With your pen draw a number of round objects which are similar in shape but different in surface: apple, egg, lemon, potato, onion, peach, tennis ball, glass globe. Or cylindrical forms: pencil, reed, brass rod, a twig with bark and one stripped of its bark, dandelion stems. Or items with a string-like form: woolly thread, wire, cord, rope, earthworm. Draw the last two categories larger than their actual size. Don't indicate the three-dimensional volume of these objects. Don't try to use shading, but just to show the nature

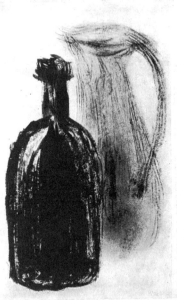

of their surfaces. Try to invent many little abstract signs and marks to give the feeling of texture.

Experiment with as many different media as possible. For instance, draw glass with the broad brush and then with the pointed pen; draw bark and wooden logs with chalk and with crayon; draw bird wings with pencil. See how many new ways you can invent for portraying surface structure, such as stippling with a brush or applying it half-dry.

You will learn that each technique has its own language, and that for each surface there is a particular way to express it best. For example, children's skin is most beautifully done with the silverpoint, which matches its silken softness.

SEEING AND DISCOVERING

Man's noblest sense is seeing.

—Dürer

Cézanne once said, "All these forms—the cone, the cylinder . . . all these favorites of mine set me in motion on sluggish mornings and excite me."

Perhaps that helps to explain the meaning of your exercises. Certainly it illustrates the reason for repeating them again and again. Just as musicians tune up their instruments before the conductor steps on the platform and experiment with trills and pluckings and odd gurgling sounds, so should you play the "serious games" again and again and let them inspire you and set you in motion.

Indeed, you should always be drawing, wherever you are, even if it is only with your eyes! And whenever possible you should be drawing in the sketch book which should be your constant companion.

Are you beginning to listen—always and everywhere—to the language of forms? The whole world is there to be looked at in creative and exploratory fashion. Fill your drawing sheets and your sketch book, but don't stop there. You yourself must become full of form inside.

You are entering the guild of strange people whose peculiarity is not only to draw on paper, to paint on canvas, to chisel stone, but to look behind outward appearances and to dissect the visible world. We do not really know what the world looks like. Photography claims to show it as it is. You

will have to acquire your own knowledge. But then, you will find appearances constantly changing during the course of your life as your artist's eyes learn to make new visual discoveries. As you learn, more and more, to experience the world through your eyes, you will look beyond the surface appearance of things and then you will make visible for others, through your art, the secrets hidden inside.

While you are learning to approach the visible world with intensity and with eyes that really see, it doesn't matter how your drawings turn out. Don't strive for mere prettiness. Don't try to produce "effective" little pictures fit for birthday presents. Your work should be an exploration, your drawings a document of your struggle. It is what is happening inside you that matters, not quick results. You are undertaking an adventure. You stand at the edge of the ocean, you learn to swim, you build a boat, you learn what water is and what it means to sail the seas!

"Confiance et conscience!" Corot used to say to his pupils. "You need confidence and moral strength."

Confidence means daring and courage, without fear of failure; for loss often turns out to be gain. And moral strength means a true understanding of yourself—not pointless, torturous self-criticism, but honesty and a feeling of responsibility.

Detail from the engraving "Adam and Eve" by Albrecht Dürer.

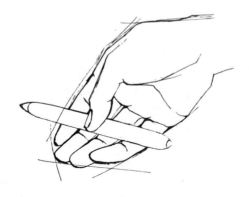

THE IMPULSE TO DRAW

A work of art which did not originate from emotion is not art. Emotion is the starting point, the beginning and the end. Craftsmanship, execution, technique are in the middle.
 —Cézanne

By now you probably have learned the size and shape of paper you prefer to draw on. Remember that in general it is best to avoid too small a scale and to draw small things enlarged. Always leave a margin of an inch or two to give yourself some leeway.

Start with light strokes by placing the pencil or chalk loosely on the inside of your fingers and holding it with your thumb. This is better than holding it as in writing for it

forces you to draw large forms and keeps you from elaborating into details. Draw lightly. Never dig. A light but disciplined pressure is sufficient even for dark lines. Only a show-off is amused by the theatrical dash of his lines.

Here is something to think about: Have the end of a line in mind when you start it! One of my teachers used to tell me again and again, "When you draw the head, look at the feet. When you draw the feet, look at the head!"

Walk away from your drawing every now and then and look at it from a distance through half-closed eyes. View its mirror image and study it placed upside down.

Construct forms from the inside out. The outer contour is the final summing up, but it must originate and grow from the inside. Volume is something that is shaped by an invisible force from inside, like a mountain of volcanic origin! Think of the cross-sections of forms and draw them.

At the beginning always include the hidden part in your drawing. Although it is not visible, it must somehow be contained in your work.

And, while you are a beginner, let each line you draw describe the form of what you are drawing. Thus you will

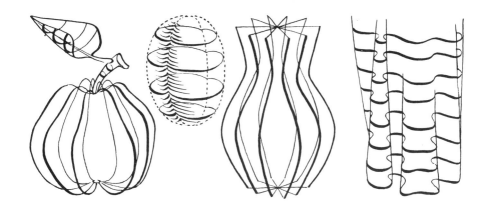

create the form anew with every stroke and you will not add meaningless lines without thinking. If you put these form-giving lines only at the essential, decisive places, you will require fewer lines. Learn to disregard accidental light and shade, for they can easily obscure true form.

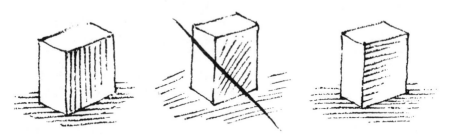

Always note proportions and observe relative sizes. Be aware of the stress implied in straight or curved lines. The back of a man seen in profile is not merely a wavy line; nor is the stem of a flower the same as a bent wire. There is always a definite contrast between straight lines, circles and curved surfaces. Study the apex of curves and notice that perfect circles or semi-circles or perfect S-lines hardly exist in nature. Notice how contrasting shapes intensify each other and try to express this clearly, differentiating carefully between slim and voluminous forms, cylinders and spheres, etc.

Test yourself to find out whether you work better from nature or from your imagination. Some people need to be constantly stimulated by what they see, while others are distracted by the variety of visual impressions. It is usually best to work out your task in your imagination until such time as you feel the need to resort to nature. Then alternate between the two methods. After you have made a drawing from nature it is a good idea to draw the same subject once more from your imagination, from memory, to catch its very essence without the distraction of details and to check up on how much you were able to grasp. "Only what I can fully

imagine, and then draw again from my imagination, have I really understood," Goethe said.

Don't confuse true creation with photographically correct reproduction. Your aim is to "translate", not merely to convert three-dimensional objects into flat planes and lines (exactly what is meant when a drawing is said to be "too objective"). That would be like tracing on a pane of glass the contours of what you see behind it! Remind yourself, if necessary, that photography has already been invented!

The secret of good drawing consists of keeping the first vision, the first excitement, alive until the last stroke! When Courbet was asked by a young painter what he did to paint so beautifully he answered, "I am moved." And when Corot was commissioned to do a landscape with the kind of branches which he painted so well, he assured his client, "You don't have to worry. I always make the branches beautiful because of the little birds."

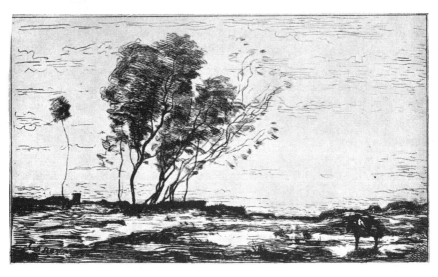

Etching by Camille Corot.

The mental challenge facing you as an artist is to produce a view *about* things, not *of* things. Your task is the transformation of chaos into unity, bewildering detail into visual clarity.

You must actively care for your subject. Otherwise it will be only an *object,* a model for reproduction. You can only paint a *subject* you love.

Don't attempt to place a thing in front of you and then begin to draw it immediately. That would be false speed. First take in what you see; experience it with your senses; touch it; meditate about it; become motivated! Let the feeling for it develop inside of you until the total experience of the thing is concentrated and crystallized in your mind's eye. Involuntarily, then, something in you will make you begin to draw!

Long ago a Chinese painter was commissioned by the Emperor to paint a picture of flying birds, to be ready by a specified date. After several weeks had passed, the Emperor was astonished to find no trace of the painting when he visited the painter's studio. Several weeks later he still found nothing, and when he arrived on the date the painting was due—no painting! The Emperor was furious. While he was trying to decide what severe and terrible punishment to mete out, the painter persuaded him to sit down for a moment. Then, before the Emperor's astonished eyes, he proceeded to paint a most beautiful picture.

"But why did you wait till the last possible moment to paint it?" the Emperor asked. The painter led him into an adjoining room where walls and floor were covered with studies of flying birds.

"I started the very first day!" he said. "I needed time to live with birds, to observe them, to take them in. How could I possibly have painted them any sooner?"

ARCHITECTURE

> *There is much more in art that can be learned, more is handed down through generations, than is commonly realized. The mechanical devices which help to produce most artistic effects—of course, it goes without saying that artistic spirit is always needed too —are plentiful.*
>
> —Goethe

Without using a ruler, practice drawing cubes, cylinders, cones and spheres in their various elevations—that is, viewed from different angles. Start with the ground plan (that is, the elevation or bird's-eye view as seen from directly above),

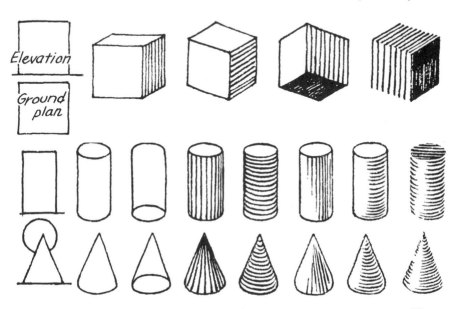

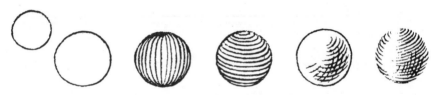

then the "simple" elevation (seen directly from in front, at eye level), and then the side views. This exercise will be the basis for many others.

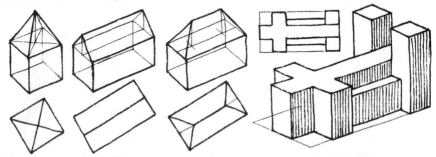

Draw a square house with a tent-shaped roof and then a wide house with a saddle roof. Simple as these forms may seem, they demand your full attention! Always proceed step by step, starting with the ground plan and building up from there with the help of auxiliary lines like those in the illustrations.

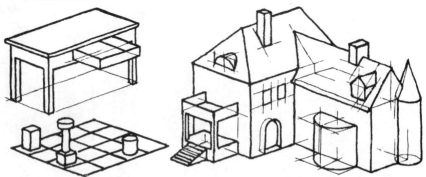

Now compose a more elaborate house complete with

such architectural details as a bay window, chimneys, stairs and windows. A helpful way to draw windows is to start with a strip and then divide it into separate windows. Draw your own house and your room, too, from memory. Don't try to rush! One neat step after another will get you there without stumbling. Make generous use of guide lines.

Round objects will be easier to draw if you describe them within a square. Notice how the curves touch the tangents.

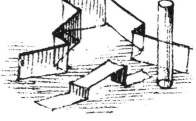

After these exercises in drawing from your imagination, try making yourself a few interesting models. Cut and fold strips of stiff paper and put them on the table, along with a slim, upright, rounded object for contrast. Draw rolled and

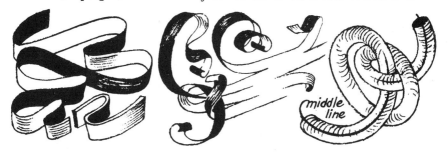

bent strips of paper. Continue with shavings, curled strips and apple peels.

Draw joints and parts of machinery, and such round things as ropes, serpents, a wrought-iron fence, a basket, a bunch of keys. It will help to draw the imaginary, direction-leading middle line through the center of the cross-section.

Draw bottles and vases with beautiful shapes, or invent some exciting contours yourself. (Remember your practice exercise with the S-curve.) Put handles on mugs, pots, funnels. Draw a house of cards, matches in an open box, piles of logs, or books, or suitcases.

How often have I seen beginners eagerly attempt the most complicated motifs! Nothing less than a full view of a

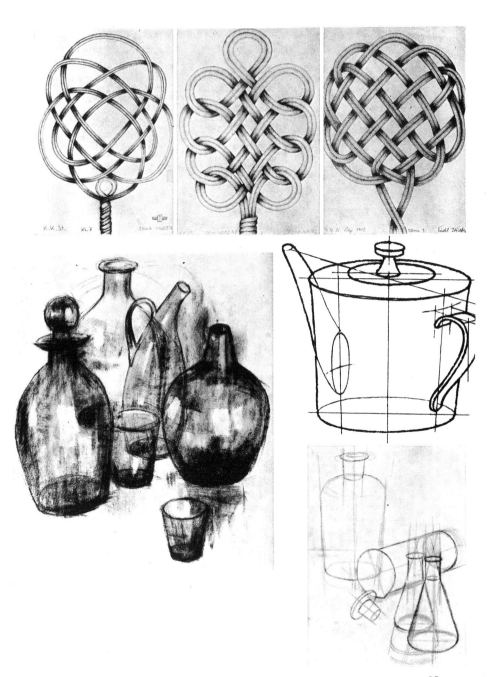

K.K.St. Kl.7 ERIKA HAUSER

61

church interior or a cloister would suffice. But sooner or later those who were honest with themselves would give it up as a bad job and then try more modest objects: a column with its capital, the profile of a window frame. And surprisingly soon they were able to succeed with the more complex tasks!

So far you have been drawing everything from one view. Now imagine you are standing on level ground at some distance from a house, and draw that house with the horizon at your eye-level. Now suppose that you are on a mountain above the house; and next, that you are in a valley and the house is on top of the mountain. Draw your observations of the house from these different viewpoints and then add a tree.

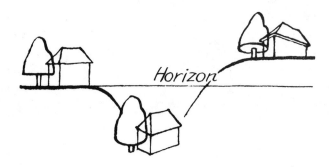

The important line is the horizon, the horizontal line at your eye-level. Vertical lines always remain vertical. The horizontal lines do not. They do not run parallel, but run towards a "vanishing point" on the horizon. The horizontal lines beneath the horizon rise towards it, and the lines above the horizon fall. Heights and distances become increasingly shorter towards the horizon, as all objects seem smaller the farther away they are from you.

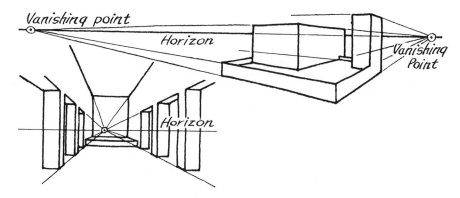

If the word "perspective" is on the tip of your tongue, you're right. This is perspective, but don't take it too seriously. You were probably taught something about it, in more or less mechanical fashion, at one time or another. When you become used to seeing clearly, and drawing what you see, you will automatically draw "with perspective".

Like a master builder, always work from the ground up. Don't concentrate on the spires and gables, at the expense of the foundation. Start with the whole and then go on to detail, but be sure you understand the whole. Walk around a building you intend to draw, and walk through it, too, if possible. Always draw the whole, never just a "view".

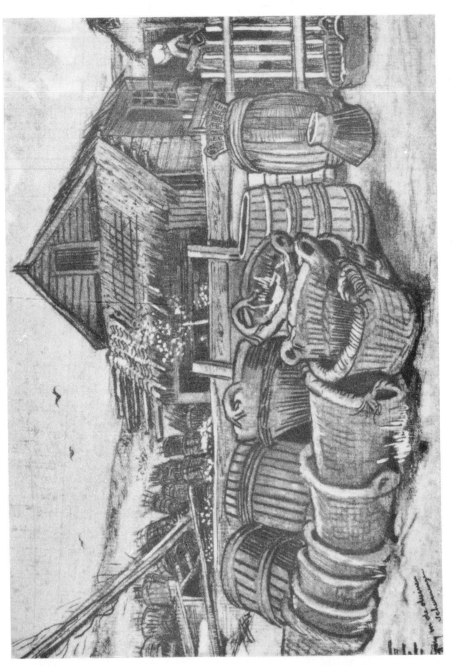

(Opposite page)
Pencil and pen,
heightened with
white, by Vin-
cent van Gogh.

PLANTS

The painter is the confidant of silent Nature. Flowers converse with him through the graceful bowing of their stems, through the softly changing colors of their blossoms. Through each flower Nature addresses him with a friendly word.

—Rodin

In a meadow, a flower-bed, or a bunch of flowers, what an incredible wealth of forms you will find! Sit down, or crouch, or lie down in a meadow full of flowers and greenery and look around. Disentangle the wilderness. Look at the outspread blossoms; at the leaves—scalloped, round, broad, slim—on graceful stems; at the gently moving blades of grass. Draw this scene—not just flowers and grass, but try to capture the music of their shapes, the delicate glissandos of the grass, the chirrup of the leaves, the chords sounded by the small plants, the high trills of the flower tufts. Fill your paper with them, one next to the other.

Then compose a scene of contrasting flowers, perhaps daisies growing in a field of clover. Make this a rolling sea of little white saucers on delicate stems, and underneath show the green, firm carpet of three-leaved clover.

Draw rows and rows of real or imaginary flowers. Then try to indicate their three-dimensional volume seen from

above and below. Collect blossoms of different shapes and continue by making careful studies of single blossoms and buds, drawing them larger than actual size.

Don't rush. There's no hurry! Through loving devotion to an unimportant, insignificant weed you will find release from the pressures of today's life. Let work like this restore your sense of values in a world whose measure of what is important or unimportant is completely out of kilter.

Make studies of the joints of leaves and stems. They are

the decisive places. Here again you must aim to draw what is not visible, and draw from the inside out. When you draw a leaf, start with the stem and the ribs and then work to the contour. When you draw complicated leaves, however, first outline roughly the over-all form.

Study the rhythmical relationship of the parts to the whole as you draw (from nature) rosettes of daisies, the rows of leaves on acacia branches, a bunch of red currants, an umbel seen from above, a tuft of moss. Notice how the parts fold together in some places and gape open at others; how the intervals alternate rhythmically in one way or another. Ask yourself where the main accent lies, and which is the essential one to which you should subordinate all the others.

Whenever you draw plants, try to work out-of-doors in

front of the living motif if it is at all possible. Even if you draw only one blade of grass in a meadow or one branch in a forest, the outdoor air and the plants, the whole ambient atmosphere, will make you *feel* the essentials more intensely than you would at home before a vase.

In any case, never draw "corpses". Picking a flower is a grave disturbance to its life and leads to its early death. When you get it home give it plenty of water and wait until it has recovered and regained some strength. You will not be stimulated by branches with wilted leaves, incongruously stuck into a vase, nor by flowers with sadly bent heads.

Arrange a large garden flower as naturally as possible, taping it to the vase if necessary. (In wintertime try one of those dried weeds with stiff umbels and delightfully curled leaves.)

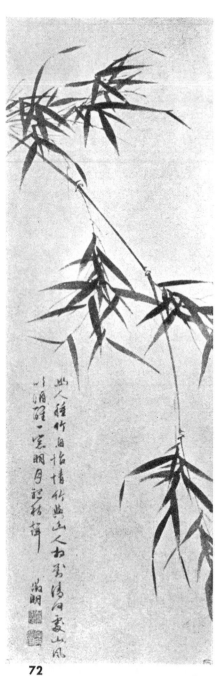

(Left) Brush on paper, by Wên Chêng-ming.

Next you must choose the most effective placement of the flower. Turn it or walk around it so that you can view it from all sides. Consider the lighting. Select the background — one which is not directly hit by the light, but is toned by shadow. If necessary put up an isolating background of paper or some other material, but don't choose a shiny white background.

Remember as you make your decisions to bear in mind where you will eventually sit as you draw. For instance, do not study your motif standing up if you plan to draw it sitting down. The difference of a foot or two in height can change the entire view.

Take your time in the planning, for you are to draw the flower as beautifully as you are capable of doing, with all its details and using all the technical skill which you possess. Have patience with yourself as you study and work. Remember, it's easy to play chopsticks on the piano, but to learn to play real music demands time, patience and practice.

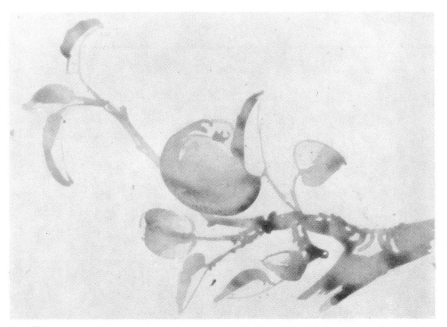

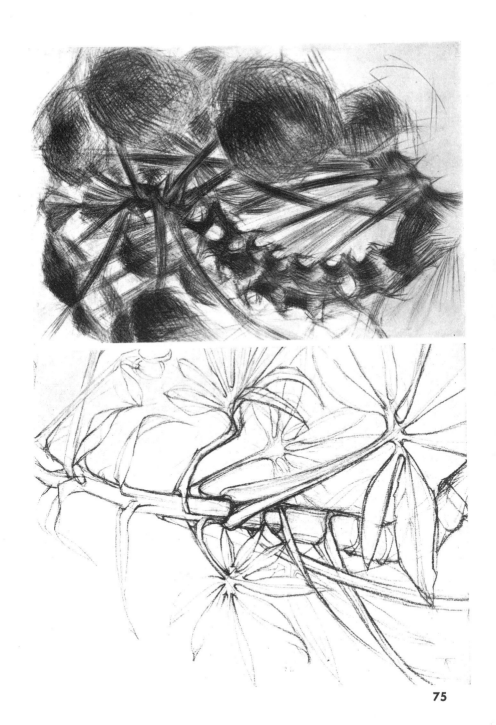

TREES

*Art should be regarded as a kind of order
imposed on the profusion of impressions
which the world inflicts on the soul; as a
manifestation of Man's life and sensitivity in
the face of Nature's immense chaos.*

—Thoma

"A gigantic beech tree dazzled me," Gottfried Keller
wrote in the delightful passage that follows, "and I imagined
that with slight effort I could master its shape."

Some time elapsed, however, before Keller decided to
draw the first line. "The more I stared at this giant, the more
unapproachable it appeared to be, and with every minute I
became more fearful. Finally I dared a few strokes, starting
at the bottom. But what I produced remained without life
or meaning."

He continued bravely to draw the tree but became in-
volved with the details and constantly fooled by the lights
and reflections. "I kept on drawing hastily, adhering timidly
to the particular part I happened to be tackling. But I was
blindly deceiving myself. Unable to relate the parts to the
whole, I betrayed my lack of form in every line.

"The tree on my paper grew enormously — especially
sideways! By the time I reached the treetop, there wasn't
enough space left on the paper, and I had to make the treetop
broad and low — like the forehead of a criminal — and force
it onto the shapeless, bulky trunk. The highest leaves touched
the edge of the paper, while the bottom hung below in

empty space. When I stood back and took in the whole effect, a ridiculously distorted caricature grinned back at me."

Study the joints of branches and draw thick branches growing out of a trunk as well as smaller branches growing out of the thicker ones. Draw out-of-doors if possible, or take a few branches into your room. An exercise which will help you to understand the basic form is to draw the branches as if they were stovepipes and then round them with form-describing hatching. Notice how the joints vary on different

kinds of trees. Some joints are abrupt and even show a sort of tear in the bark, while others are softly "smudged". Draw the joints of many varieties of trees, rounding the basic form and also indicating the special quality of each particular bark.

Draw an interestingly composed group of trees, paying particular attention to the spatial relationship of the trunks. Here again, as with architecture, the important zone is the ground where the trees break through the surface of the earth. The beginner may be tempted to give only vague indications, but you should make clear how the trunks emerge from the ground. A practical suggestion is to continue the roots downward even though you can't see them, marking the point where they push through the earth's crust.

Study the shapes of various kinds of trees and notice

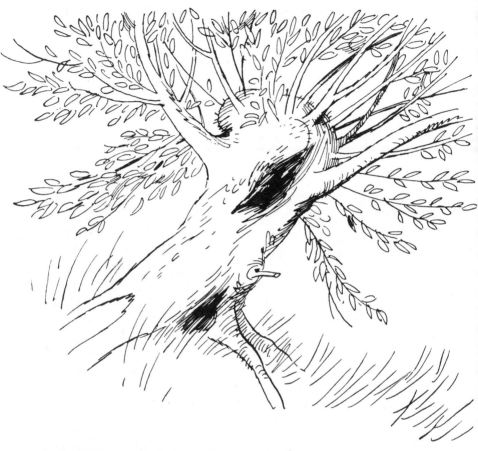

how different their branches are — some gauntly stretched, others gracefully suspended, jaggedly distorted, steeply up-rising, or bursting in starlike clusters. Study the small branches, too — flickering, dentated, loosely swinging, or resembling little hands with outspread fingers.

The best time to observe and make studies of branches is in the autumn or winter when the leaves have gone, or in the spring before the buds open into leaves. Make your sketches out-of-doors, of course, but do the finished drawing

at home. Draw several species of trees on a hill or an island. An interesting variation is to draw trees in a storm. Study the way they move and note which trees are strong and which shake and bend.

During the summer, when the trees are in full leaf, cover sheet after sheet of paper, higgledy-piggledy, with as

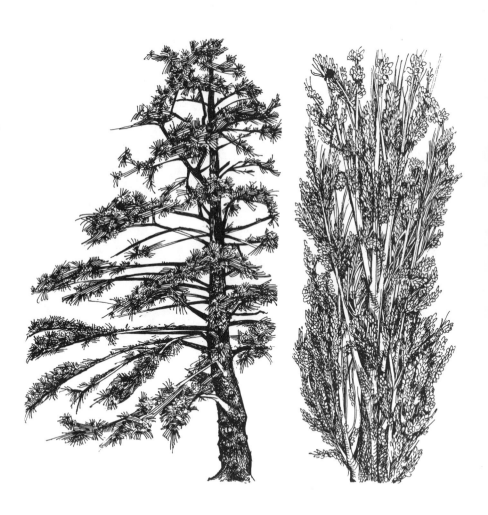

many different kinds of leaves as you can find. On shrubs
and trees, Nature has provided an infinite variety of leaves
— the round, flat leaves of lime trees, the lance-shaped leaves
of willows, star-shaped leaves, ovals, some with scalloped
edges and others jagged, and the big hands of chestnut leaves.

Some leaves grow in clusters, others in rows, some paired
and some alternate. Some leap up like flames, and some
cascade like waterfalls. Don't copy too slavishly, but invent
little squiggles which resemble them enough to identify
them.

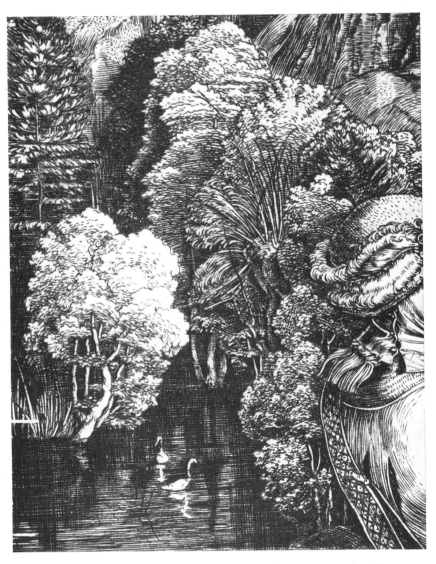

Detail from the engraving "Saint Eustace" by Albrecht Dürer.

Before you attempt the bulk of treetops, study their flat contours. Draw lines on your paper and sketch between them the silhouettes of various trees with the simplest indications of their main branches. Try to get the relative sizes correct for different varieties, going above the line for high-reaching trees. Gradually you may try to fill in the silhouettes and to describe the leaves and use them for more detailed delineation of the contour.

Of course, in reality trees are not flat but round. Some

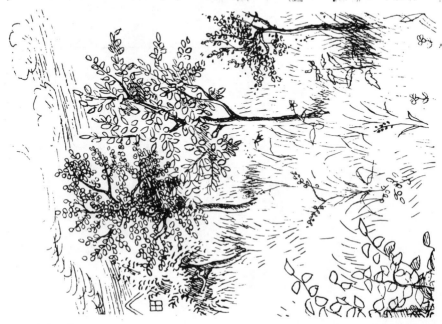

treetops, strong and mighty, rise like steps, a d you can climb from branch to branch. Other spread ut like umbrellas, protecting you from rain. Take your chalk and draw massive treetops from nature and from imag nation. Simplify them to their basic shapes — spheres, cones with their peaks pointing up or down, upright cylinders, piles of disks, billowy cushions. Using that same style, draw single trees,

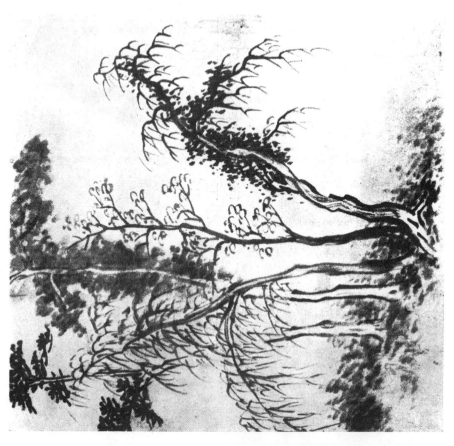

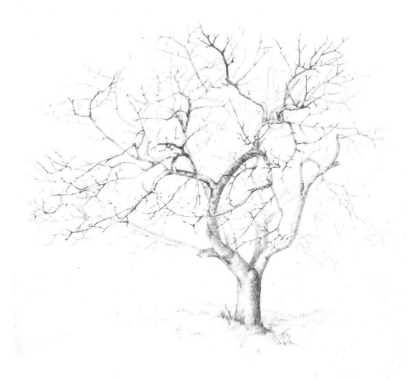

groups of trees and even the edge of a forest. Now take a large sheet of paper and your favorite medium and spend hours drawing one beautiful tree, complete in all details.

Detail from an etching by C. W. Kolbe.

LANDSCAPE

Landscape reflects itself in me, becoming human and comprehensible.

—Cézanne

Landscape is a general term for outdoor subjects including trees, houses and plants. What is near you? If you live near a lake, you can paint the shimmering mirror of its surface. Perhaps there are hills rising from its edge, or a row of trees bordering the far side, or a spit of stony land reaching out into the water.

Do you have a view from the hills? Or do you live in a valley enclosed by steep slopes covered with dark masses of trees? Or is yours a flat, open land, stretching out endlessly, with only an occasional farm house under sheltering trees to arrest the eye? Even if you live in a big city, you can find a landscape to draw. It may be a spot in a park, or a vista through city streets.

Wherever you live, wherever you are, try to extract and

Detail from the engraving, "Nemesis" by Albrecht Dürer.

absorb the rhythm, the special language of that landscape. Imitate its expression with your own facial expression. Then try to draw your impression of the landscape, without details, but trying to show its character, its symbol.

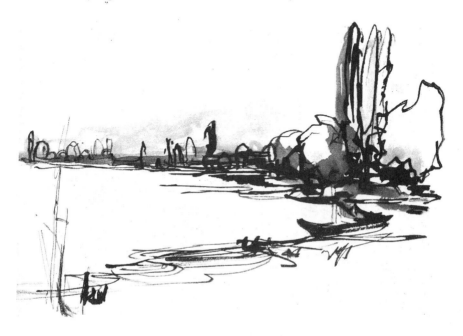

Remember in sketching a landscape that the ground and its structure, as always, are most important. Everything rests on them. Try to visualize how the cross-sections look, and employ this knowledge in your hatching.

Study the essentials of landscape in a gravel-pit, in a quarry, in a gorge; even a pile of sand will do! Aim at clarity and a three-dimensional feeling rather than "arty" effects. Every line should express the slope, the overhang, the flatness, the upsurge, the smooth descending of the structural forms of the landscape. Think of sleigh rides, of skiing and climbing. Picture all elevations as of volcanic origin, as if

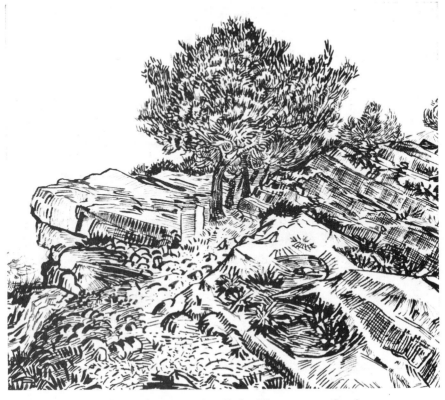

Reed pen drawing, detail, by Vincent van Gogh.

pushed up from below; and all valleys as if you had just seen
them being cut out of the earth. If you experience landscape
that way, a gravel-pit can become an alpine landscape in your
drawing!

Rocks form a part of many landscapes. When you draw
them, study both their cubic form and their material suface.
Are they closed blocks or full of cleavages? Are they piled
on top of each other? Are their surfaces dull or glistening,
granular or scaly, or smoothed by the sea?

YOUR TALENT AND ITS DEVELOPMENT

If you are still acting the dual role of pupil and teacher, now is the time to pause for a session of self-evaluation.

Are your drawings patient and quietly receptive, like Chinese art, or forcefully aggressive like Rembrandt? Is your manner softly flowing or constructive and robust? Are you filled with inner visions and the urge to express yourself, or are you more realistic? The drawings of different readers will be just as different and as characteristic as their handwriting.

Decide what your special aptitudes are and beware of the seeds of danger inherent in each. If your lines are sure and facile—a laudable talent, of course—you may be prone to routine; to decorative play; to prettifying. If you are particularly fond of details, beware of drawing too small and too fussily. If you have a quick eye and a clear understanding of forms, watch out for repetition.

If you strive continually for expression, and your lines sound and sing, stop and ask yourself whether this is not just a lot of empty noise, and whether you have produced clear forms or cheap effects. If the world appears to you in rainbow hues or in light and shade, you may tend to neglect form and structure.

Everybody has at least a bit of talent. Your talent will be sufficient if you know how to use it. Drawings from imagination are always a good test. They show you how much you have understood of forms and meaning and what you are able to produce.

You have to discover your potentials for yourself. Be

modest. Quality does not depend on quantity. A fine work has a value all its own. Do not push a slight talent, if that is what you possess, too fast. Instead of doing difficult assignments, limit yourself to lesser problems and handle them really well. Draw plants instead of entire gardens, trees instead of landscapes. Go on only when you feel the urge to do so. Reach for materials with richer qualities—take chalk when the pen does not suffice. On the other hand, don't stay "primitive" with the excuse that that is fashionable today. The genuine primitives and the children will put you to shame!

While you are drawing, devote yourself completely to your work and do not reflect. But between drawings, and before and after, you must think about where you are and where you are heading. Don't forget that you are your own teacher. Check and correct yourself.

As Cézanne says, "The painter needs two things: his eyes and his brains. Both have to help each other. It is necessary to train them both. For the eye there is the study of nature, and for the brain, the logic of ordered impressions."

Between exercises you should draw whatever comes to your mind, not in a messy and careless way, but not too fussily, either. Try to make a real picture, giving vent to your ideas. Fill up your paper to the very edges and into the corners. That forces you to learn how to compose a picture. Get up from your work every now and then and stretch yourself, and then check your drawing from the distance before going back to it.

THE HUMAN FIGURE

Let Corot tell you about the first few times he attempted to draw figures: "Two men stopped near me for a chat. I wanted to sketch them, and began with their heads. But then they decided to walk on—and all I had on my paper were bits of their heads! Another time I saw children sitting on the steps of a church, but as soon as I began to draw them their mother called them away. In this manner I filled my sketch book with noses, foreheads and hairpins. I made up my mind never to go home in the future without a complete drawing. Now I started to sketch very quickly, for with this type of work it is the only possible way! I would sit down and quickly encompass a group with my eyes. If they stood still for even a few moments, I could get a general idea of their character and their pose onto paper. If they remained longer, I could add a few details."

The drawing of the human figure requires a model—one that is available to you at all times. One model who will always pose for you is yourself. Stand with your weight distributed on both legs, breathe and imagine that you are a column suported by air. Now bend your left hip and left knee forward. Your torso is held by the right hip, which as a matter of course has moved to the right. Your right leg, too, must move in order to maintain balance. Now repeat on the other side, and put your right leg, which is the non-weight-bearing one, a little to the side. Describe circles with it without moving your weight-bearing leg.

Now move your weight slowly over to the right leg. In

the middle of this movement there is a point where you stand balanced on both legs. Further on your right leg becomes the weight-bearing leg, the left leg becomes the non-weight-bearing leg, and the right shoulder drops a little.

Look to the left and turn your head in the same direction. You will notice that your right shoulder moves forward a little all by itself.

Divide a sheet of paper into several horizontal strips about 3 inches high with narrow intervals between them. With pen or ball-point pen draw into these strips all the poses which you have just practiced by your various weight-shiftings. Don't draw single-line "stick men", for the body is full and round. Note that the torso is a rectangle which gets narrower as it goes down. A useful practice line is the vertical line that extends from the sternal notch to the heel of the supporting leg.

Make your figure put a hand first on the supporting hip, then on the other. Draw the figure resting evenly on both feet, arms akimbo. Alternate with drawing and acting out poses yourself.

The way to draw these figures is in one swift movement, without lifting your pen or pencil from the paper. Don't rest your hand on the paper, and hold whatever material you are

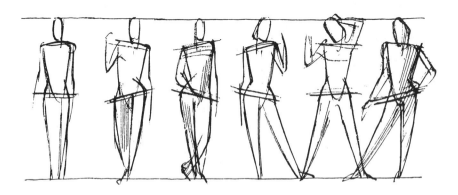

using in the style described on page 52. Don't let your pencil stutter. You must continue the movement, often across the body, from the right leg to the left shoulder, in what I call a "monogram".

Try to decide what elements each move consists of and which are important, which subordinate. Never draw until you are sure you understand the movement. Act it out your-

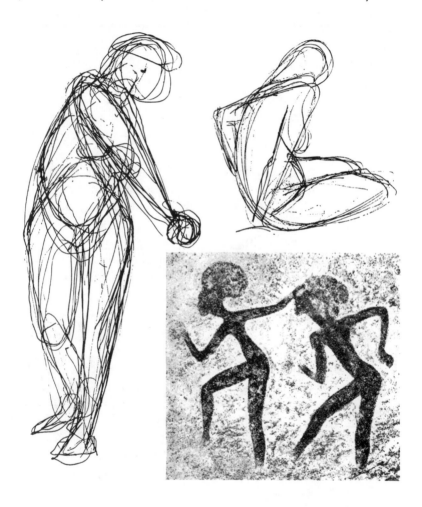

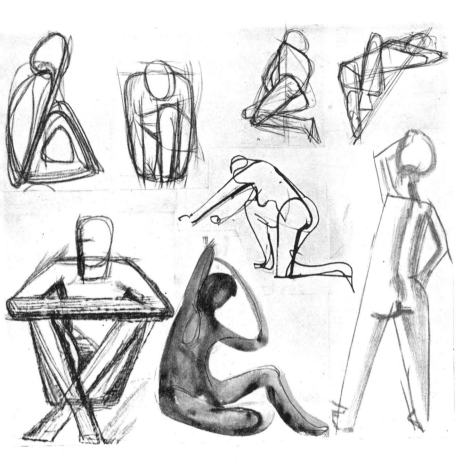

self first. You can actually do this without moving much, sometimes even sitting down, if you simply imagine it happening inside you.

The entire body is involved in each movement. Do not just place the head on top of the body, for it too takes part in any movement. In fact, when you want to draw the head, start with the legs! Take large sheets of cheap paper and draw in large terms. Using flowing, sweeping movement, draw all over the paper, making one drawing over another. This will give you courage and make you pay more attention to the

general conception than to the single line. Let your drawings tell of your struggle. Always sketch the entire figure, including head and feet.

Draw the human figure from memory as well as from models. When working with a live model, draw the same position from many angles. Walk slowly about the model, and always look for the meaning of each movement. Note where the model is looking, what the model is doing, and what the movement expresses.

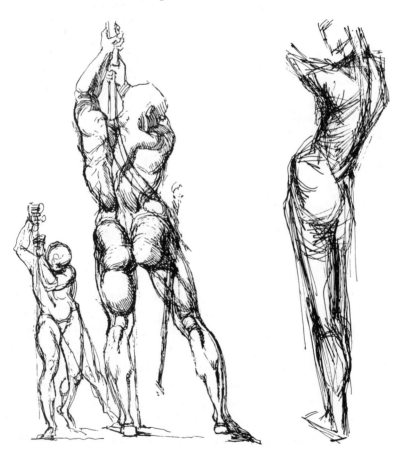

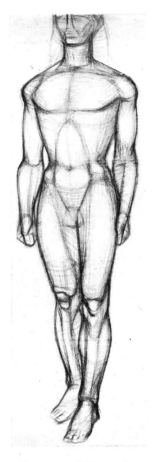 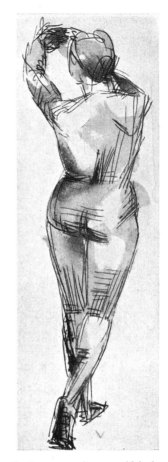

Beware of "learning anatomy". It can ruin you if it leads you down the wrong path. Anatomy is necessary to help you understand what you see, but not from the medical viewpoint. Study anatomy from the artist's viewpoint, in front of your mirror where you can see everything yourself, and even feel it with your hands.

You have already seen how important the hips are in figure drawing. The diaphragm is also important—so much so that the Greeks, that nation of sculptors, imagined the dia-

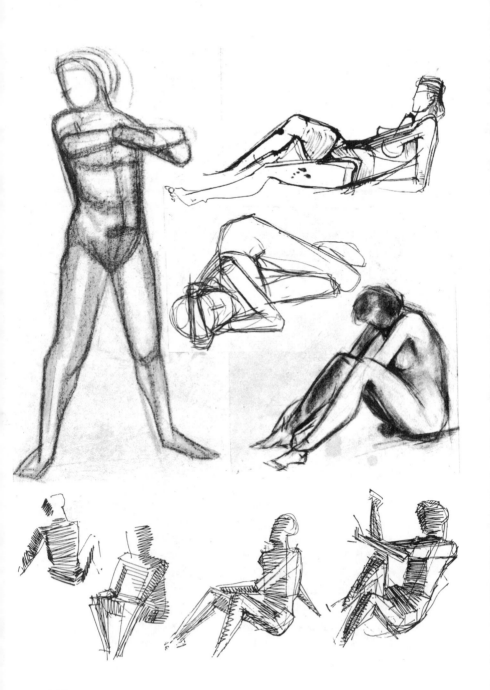

phragm to be the seat of the soul. From it every movement radiates, for through it each movement of the legs is transferred to the upper body and arms, each movement of the right side to the left. Think of each movement as originating there.

Study and feel your bone structure. Attached to the spine is the rib cage and beneath it, the pelvis. The rib cage is widest at its lowest point, the pelvis at its highest point. And yet the torso is broadest in its upper part, because of the shoulder girdle which widens the upper body. The shoulder girdle is made up of the collar bones and the shoulder blades. It is very mobile. The legs are connected with the pelvis through the hip joints. Arms and legs consist of two parts each with hands and feet at their ends. The spine extends above the chest structure and becomes the neck, on which the head sits with most of its weight forward. That is why the head falls forward when you feel sleepy.

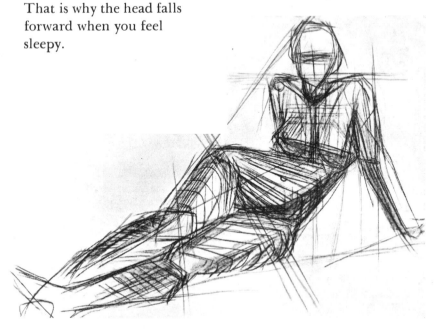

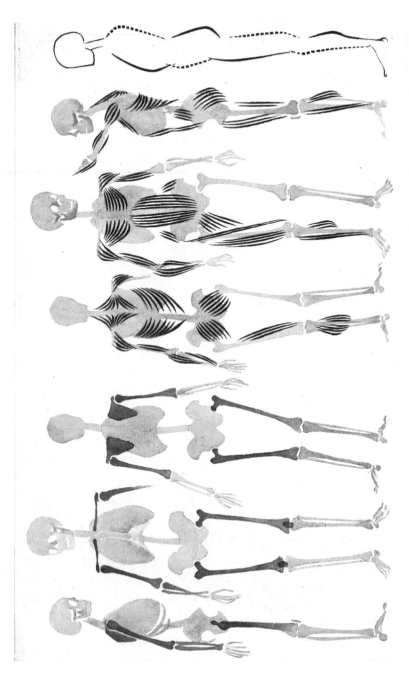

Draw skeletons in motion.

You noted earlier that the body is full and round, an object in space. But previously you concentrated on drawing over-all movement and you connected all the parts in over-simplification. Now you are going to separate them and put them together again with a new approach. You will draw neck, rib cage, shoulder blades, as important and separate parts and not connected through one line.

A useful exercise is to construct bodies of cubes, rect-angles, spheres and cylinders. Before you start to draw, try to form a human figure of geometrical pieces of clay. Cubism is not an end in itself, but an experiment to teach you how the limbs of the body relate to each other in their three-dimensional aspect. See how the lower arm is set against the upper arm at a 90° angle; how the knee is really part of the thigh; and how the tower of the neck sits on the highest point of the chest. Study, too, the space which is enclosed by the body. For example, consider the room between the trunk, thighs and upper arms of a person sitting with his elbows on his knees. This is similar to the exercise with buildings, where you studied the open space of village squares and streets and alleys created by the houses.

In order to study hands and feet you must make a pre-liminary excursion into the field of sculpture once again. Use clay or plasticine to form the parts of a hand: a cylinder for

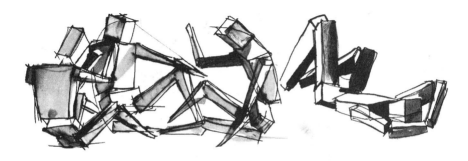

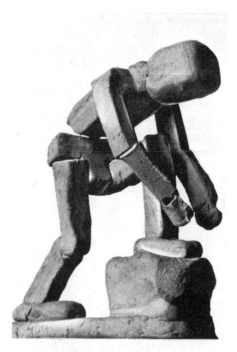

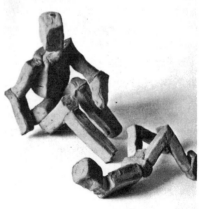

the arm, a flat block in the shape of a trapezoid for the palm, four fingers like frankfurters, a thumb-ball and a shorter sausage for the thumb itself. Connect the palm with the arm. Where? So that the palm protrudes over the wrist. Then the fingers. Where? So that the knuckles show from above, appear hollow from below. Now place the thumb on the thumb-ball and add that to the palm so that the thumb stands opposite the other fingers. Do not smear over the joints. You'll be surprised at how quickly and precisely you can form a human hand!

Now make the opposite hand, and play with them and make them do things. Then draw them, but always in action. Concentrate on their function and draw them pointing or

holding something. Draw simple hands in action from imagination, too. Only after this preliminary training should you draw from nature.

The same applies to the foot. Form the parts of clay: a cylinder for the ankle, a longer trapezoid, the toes, the heel. Join these parts, bend them, study them, and draw them.

In order to familarize yourself with the human figure, draw rows of little squares and fill them with figures. This will stimulate your inventive powers and increase your sensitivity of form and movement. First let your pen or pencil run around the square frame several times; then dash very decidedly into the square with a certain direction out of which the figure will develop almost by itself.

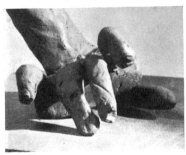
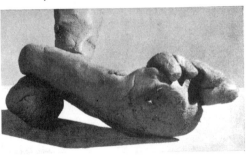
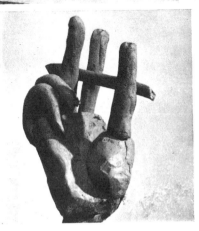
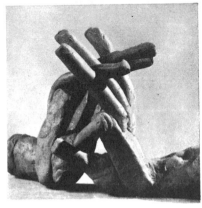

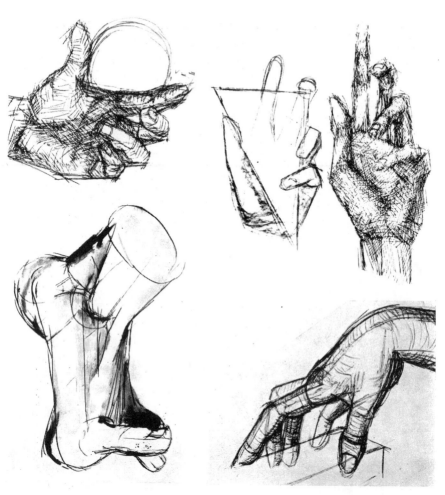

Observe how the parts of the body relate to each other —the head to the whole body, legs to trunk, and so forth. Observe how these ratios differ with babies, children, men, women, old people. Sketch rows and rows of figures of people of all ages, using the height of a grown man as your standard of comparison.

You have been considering bony structure, and now it

is time to study the important muscles of the body. They are the most active parts of the body, serving to bend and stretch the limbs. As they can only pull but not push, a pair of them is needed for every movement. When one is tightened, the other is loosened. The large stomach muscle rules over the torso. To right and left it is assisted by oblique muscles. Chest and shoulders are connected by the big chest muscles. The deltoid muscle stretches over the shoulders. In the back the trapezius muscle is important. It connects the neck and back. There is also a layer of large muscles which span the rib cage. The back of the pelvis is covered by the buttocks.

On the thigh the long and narrow sartorius muscle separates the strong outer triceps of the thigh from the inner tightening muscles, the adductor group. In the back of the thigh is the hamstring muscle which bends the back of the thigh. The visible muscles of the lower leg are in the calf and a long muscle over the fibula, or shin, in front.

The angular shape of the upper arm and shoulder is caused by the biceps in front and the triceps in back. The main muscles of the forearm are the flexor group which bend the hand and fingers, and the extensor group which extend the hand and fingers.

Some muscles are more developed in a man, others in a woman. Always think of them as forms and shapes, not as just muscles. Now perhaps you understand better why the silhouette of a body in profile shows such an interesting play and counterplay of curves, with constantly alternating and shifting apex.

Now draw figures with chalk on large sheets. Construct large forms with sweeping lines that come—literally—straight from the shoulder, without resting your hand on the paper. Check the main vertical line from the pit of the neck down, and also the main horizontals: shoulders, pelvis, knees. Indicate the important middle line from the pit of the neck to

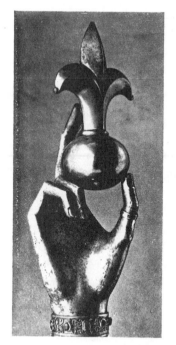

the navel with its telling curve. Never concentrate too much on accidental contours. Mold the body from the inside out; construct it! The contour will follow of itself.

When drawing nudes, every change of direction in the outline of the figure should make you ask yourself, why? Always indicate clearly where lines overlap and don't let one line run vaguely into another. Again, draw what you know is there, even though you don't see it. Always picture the body when drawing a clothed figure. Do not draw garments, but human bodies dressed in clothes.

Draw a figure in outline alone, making it contain as much of the inside as possible. Next, mould with hatching only, with no sharp delineation of the contour. Use hatching

to follow the form, not to indicate temporary shadows. Don't hesitate to add cross-sections to help you understand what you are drawing. Walk around the model repeatedly and follow the change of silhouette, the overlappings of lines.

So far we have only scratched the surface of drawing the human figure. It is at this point that the real adventure begins—a richer, more subtle surface relief, the joints, the

(Opposite page, top left) Reliquary of St. Sigismund, Guelph-treasure.

(Top right) Pen sketch by Albrecht Dürer. (Below) Pen sketch by Michelangelo.

tightened and loosened muscles—but that goes far beyond the limits of this book. Our advice to you now is to try out different media and ways of expressing the human figure: white on grey paper, a paper cut-out, a clay figurine. Follow the advice of Rodin: "Most of all make clear the bulky parts of the bodies you are creating. Emphasize the position of each part—the head, the shoulders, the pelvis, the legs. Art demands firmness and determination. Conquer depth and space with decisive, meaningful lines. Once you know what you are doing, your work will come to life. In drawing, look out for sculptural forms rather than mere outlines and success will soon be within grasp."

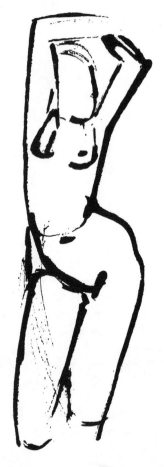

THE HEAD

Conceive each surface as the outside of some-
thing that presses from within. Experience all
forms as directed toward you. All life origin-
ates from a central core; it sprouts and begins
to blossom from the inside out.

—Rodin

A head consists of the face and the back of the head, or cranium. It is a typical beginner's mistake to consider the face more important than the back of the head, but you will learn how untrue that is by studying profiles. Study the relationship of the face to the back of the head, the inclination

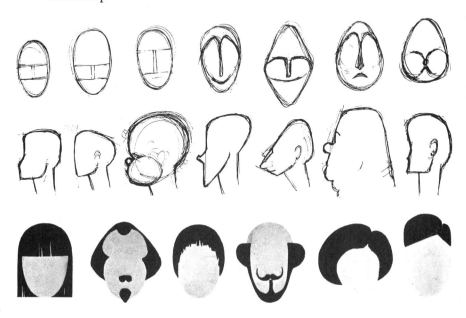

of the head, the protruding or receding chin, the proportions of forehead, nose and mouth. As to the nose, don't make a second common beginner's error of thinking its shape is more important than its relationship to the other parts of the face.

For a warm-up exercise, make silhouette cut-outs of many different heads. Now draw different faces in frontal view, with simple lines, paying special attention to the relationship of forehead, cheeks and mouth. Watch the relation between height and width of all parts.

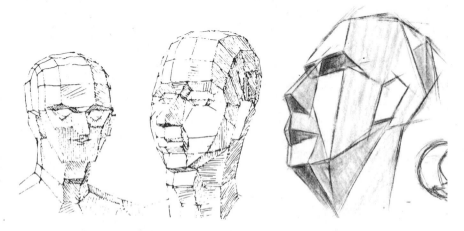

Study your own head in the mirror from all angles; touch it and explore it with your hands. Note the large rounded back of your head and the three main factors of the face—the forehead, cheeks and jaw. The forehead and cranium are immovably connected, the jaw bone clearly separate. Draw the structure of heads from different angles in simple cubistic terms. But don't bother to draw skulls. They won't help you unless you simply want to draw skulls for their own sake!

The features that seem to fascinate beginners most— eyes and mouth—are really the frosting on the cake. They come last, not first. Holes must be carved before the eyes can

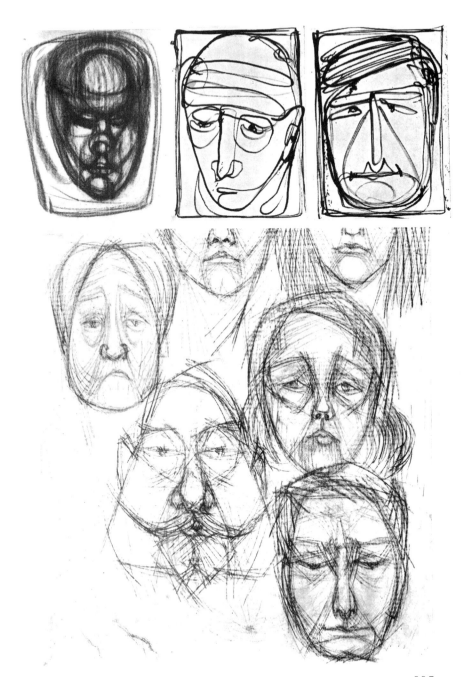

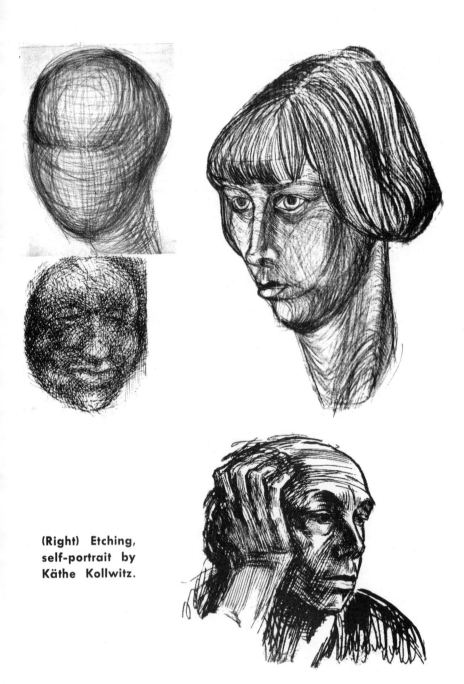

(Right) Etching,
self-portrait by
Käthe Kollwitz.

be set, and the lower part of the face has to be constructed before the mouth can be cut into it! That line is far more important than the outline of the lips, which always seems to be of greater interest to beginners.

A word about hair. Hair has form, no matter how short it may be. It is not just a dark mass, or straw, or tangled wire. But what about messy, uncombed hair? My advice is to deal first with combed hair! You may think that trees are easier to draw than houses, or jellyfish than snail shells, but the opposite is true. They are more difficult to draw because their shape is more difficult to grasp and understand. For, to reproduce what seems confused does not mean to draw messily, and to reproduce what seems undefined and half-hearted does not mean to draw equally half-heartedly and without definition. To begin with, then, comb and construct a hair-do and pretend that it is made of plaster. Later on it will be easy to give it shine and color.

Devote many separate studies to nose, eyes and ears,

drawing them from different angles. Draw each feature with a little of its surrounding setting, first from life and then repeat from memory. Drawing parts of the face from imagination will make you see more sharply when you again work from life.

Wrinkles in the face are the result of sudden meetings of different forms and planes. They define shape, and are not simply lines that are painted on, like make-up.

The face is incredibly full of movement and expression. Try drawing quick sketches of expressions, grimaces and caricatures as you drew the figure "monograms" on page 31. Draw little and big squares and fill them with free-flowing sketches—not portraits—of faces that are astonished, grinning, dogged, grim, frightened, jubilant, etc. Then fill one

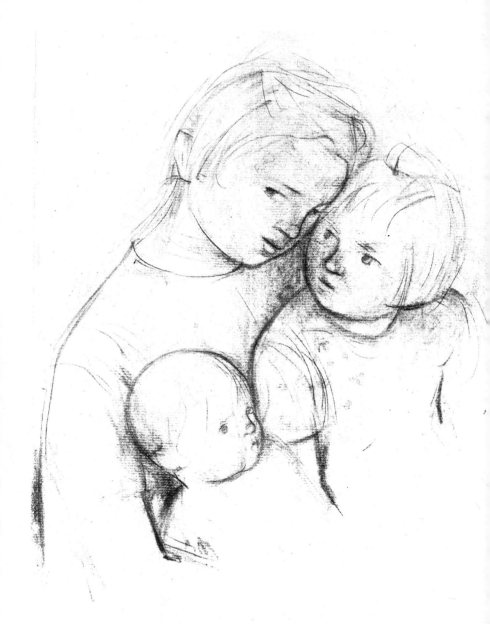

Chalk, "Children with a Doll" by Hans Theo Richter.

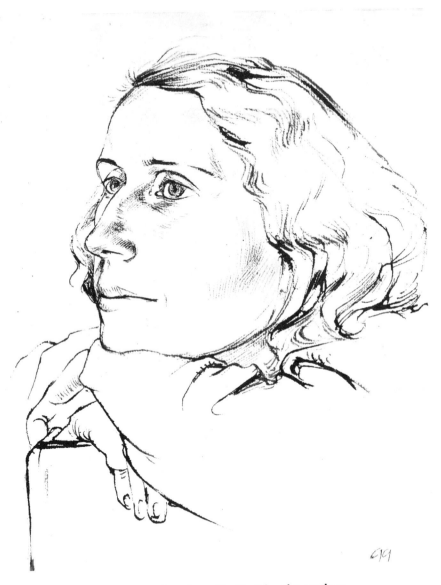

Reed pen drawing, "Lalita" by the author.

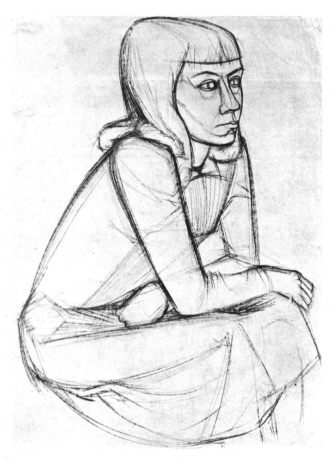

paper with several large heads, overlapping them to cover the page.

Draw one face that particularly interests you and finish it to the last detail. Try to achieve a real "likeness". What gives a portrait "likeness"? Not copying nose and mouth exactly, but clearly grasping and portraying the directions and masses and the relationship of the parts to each other. However, the problem of likeness shouldn't occupy you until you feel that you have mastered all of the single elements. Wait

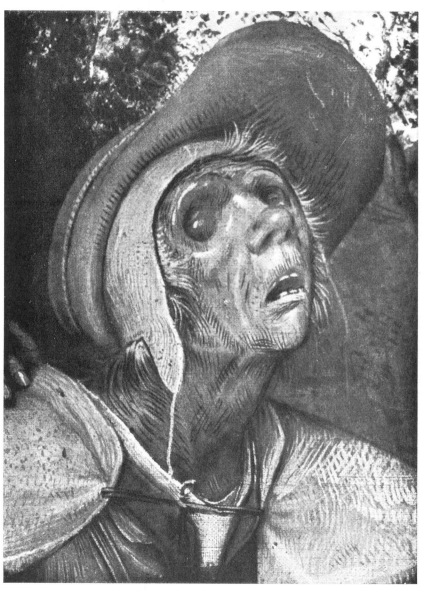

Tempera on canvas, detail from "The Parable of the Blind" by Pieter Brueghel.

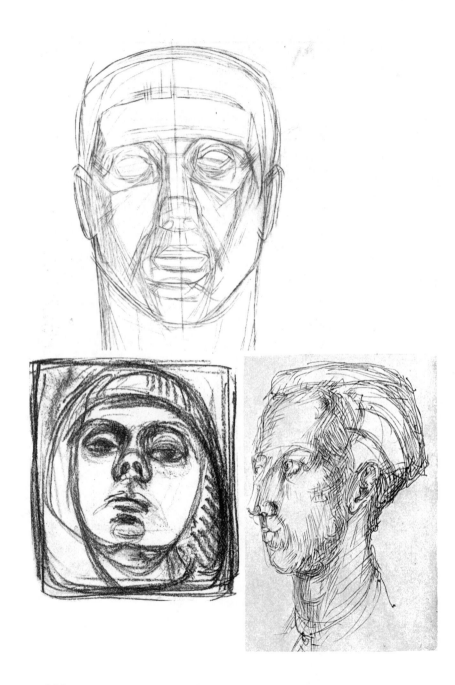

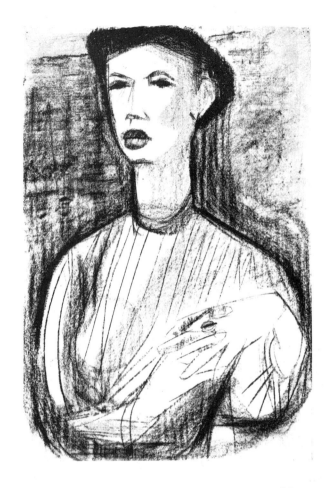

until one particular face interests you as an artistic problem —rather than for its human interest. But don't deceive yourself by pretending that you know muscles you have never studied; by producing a rich surface through clever but superficial hatching; or by sacrificing artistic unity for likeness.

ANIMALS

You should be able, at this point, to teach yourself to draw animals without any further specific instruction. Use the same steps and the same exercises which you followed for the human figure. Start with observation of live animals. Then draw the brief impressions—the "monograms"—which give you a feeling for the whole animal. Next proceed to the cubistic drawings and clay modelling, then the study of skeletons and muscles, and finally work on the details which always come last.

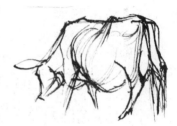

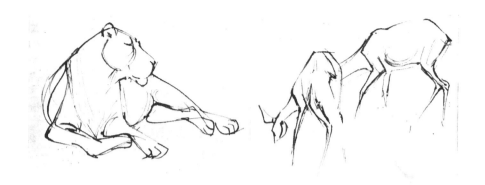

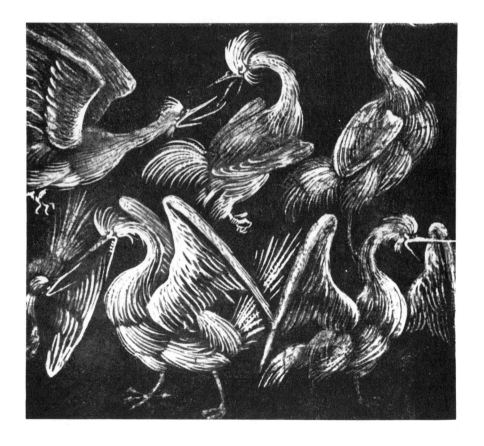

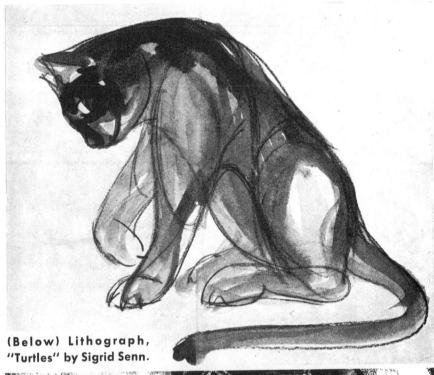

(Below) Lithograph,
"Turtles" by Sigrid Senn.

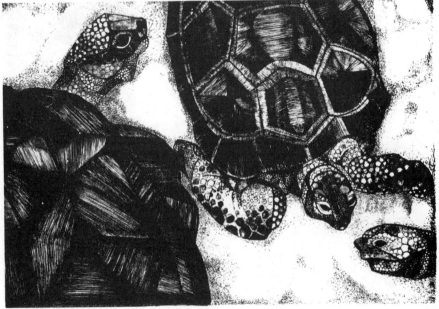

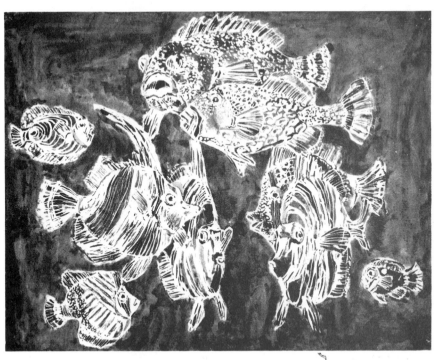

LIGHT AND SHADE

See these finely executed drawings with their careful gradations of white and black? They are the homework which I still impose upon myself to this very day.

<div align="right">—Matisse</div>

The human eye sees tones and shapes, but not lines. Lines are abstractions which man has created, but "lines" do not really exist. So far, lines have dominated your work, but now you must begin to study tonal values—light and shade.

Mark a sheet of white paper into squares of about 2 inches and then fill these squares at random with black plus two clearly different shades of grey. Use either pencil or chalk, or a brush with ink or water color. This gives you four tones, including black and white.

Repeat the same exercise on light grey paper. This time you must produce the white by "heightening". The tone of the paper itself becomes the first grey, while deeper grey and black supply the third and fourth tones.

Next draw stripes of different widths using shades of grey ranging from white to black. Continue a rhythmical repeat of the stripes until you have a pattern. Try it with various media. Exercises such as these force you to make pre-

cise statements about light and shade instead of simply smudging in impressionistic shadows.

Continue to learn more about light and shade by playing with gradations of tones. Fill several sheets with varied tones, placing some sharply against each other and letting others melt softly together.

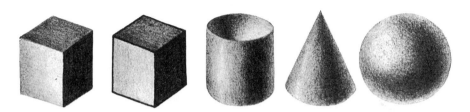

With a soft pencil draw cubes, cylinders, cones, and balls by means of shading only, with no delineations. Notice the difference between the shadow on the object itself and the shadow thrown by the object. Then put a definite line around your object—as shown in the second cube of the illustration. Isn't it astonishing to see how the effect that you had produced is immediately destroyed and negated? This illustrates graphically that when you work with light and shade, you cannot use lines except in a secondary capacity.

Walking between the trees of a forest, look with half-closed eyes at the harmony of light and shade under the trees. Let your eyes and your mind feel the rhythm of distances between the tree trunks, the timing and the syncopation. Then compose a chiaroscuro sonata from what you have seen. (The term chiaroscuro means a light-and-shade sketch.) Concentrate more on the space between the trees than the trees themselves. Instead of molding trees, break up the space of your paper with variously-toned bands which are the trunks. In your next drawing enrich the polyphony of tones by adding accents in direction, such as a quivering

young birch tree crossing the vertical rhythm of a sturdy, erect trunk.

Chiaroscuro supplies you with a new kind of perspective, aerial perspective: The further away from you an object is, the lighter it is. Therefore you have to draw the background lighter and with less accent than the foreground. Draw a group of leafless trees from memory with your pen. Or, using chalk and a kneaded eraser, draw a landscape such as a lake and the land beyond it, arranged in depth like stage scenery.

Work on motifs which lend themselves specifically to chiaroscuro treatment, such as clouds, smoke and water. But remember that you cannot achieve cloud-like, wavering effects simply by drawing in a woolly, indefinite manner! Invent clouds of your own if the sky won't produce any. Con-

trast towering, fluffy white cumulus clouds with the dark, slim, horizontal clouds that often resemble floating fish. This time use charcoal, your fingers, and the eraser on textured white paper. After that try toned paper, using white and black chalk.

Draw something round and solid such as a vase, a rosebud, or a head in chiaroscuro. Do not affect unnecessary embellishments, but create with tones as you did before with lines. The tonality should not destroy the forms, but reconstruct them anew. Tone is not an incidental shadow but another architect of form.

In this type of work the whole expanse of your paper is important. You cannot tone your object alone, for only through treatment of the whole space can you make the lighter areas authoritative.

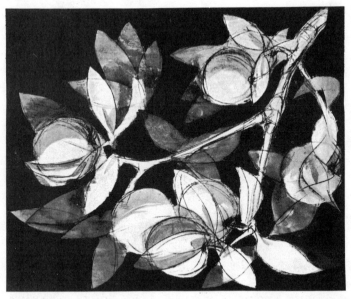

Do very little preliminary outlining—mere indications, really—and start right in with tones. Beware of using black

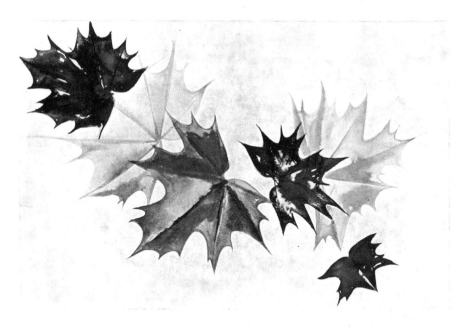

too soon. Always save your best possibilities for the end, just as a good general saves his reserves, or as an actor reserves his most effective devices, the exclamation and the whisper! Save your black for the most effective spots.

Perhaps the best way to start is with a wash. Use a brush and thinned-out ink or pale water color on slightly absorbent paper. Don't use paper that is too absorbent or the tone values will change as the wash dries. On the other hand, if the paper isn't absorbent enough, your tones will run into each other. Regard your subject, and your drawing, with half-closed eyes in order to keep away from petty details. Think about the different gradations of tones before you begin to draw, and distinguish between tone value and color value. For instance, red has a stronger tone value than blue.

Between the two poles of tone drawing and line drawing there are many interesting possibilities. You can do a pen-and-wash drawing, where the main accent is on the lines. The

lines are then enhanced and pulled together by the wash. Or you can compose a drawing entirely in terms of tones, using the pen only for the framework. Or start with tones alone, without any preliminary drawing, and then as a second step add pen lines either after the wash has dried, or else to the still slightly wet paper.

Line characterizes and abstracts, while tone gives mood and body. Some people use light and shade only for toning

a drawing, while others fall completely under the spell of chiaroscuro. If you are one of the latter, you may discover that, in contrast to what has been said above, values in the distance appear darker as your eyes are drawn into some velvety dark depth. You may begin to feel that the lines which have served you well for drawing, up to now, seem too hard, too banal, almost too brutal. If that happens, you will be at the threshold of a new territory—that of painting!

COMPOSITION

Drawing is the original source and soul of all painting and the root of all art. To him who succeeds in learning to draw I say that he owns a precious treasure. For with the brush he can create figures higher than any tower which can be cut out of stone with a chisel.
—Michelangelo

So far most of your problems and exercises have necessarily involved learning to draw isolated objects. Often you had to separate the reed from its brothers and sisters, the tree from the forest, the figure from its partner. Your next adventure will be devoted to co-existence—the community of things and figures which is known as "composition". What a misleading word that is! To compose means to put together, but that isn't exactly what you want to do. Neither do you want to reproduce arbitrarily some chance view taken from nature. What you want is to create a well-organized unity with all its parts related.

Take a walk and stop as soon as some view—a group of trees in the distance, or a street scene—amalgamates and becomes a picture. For surely, out of the inexhaustible visible wealth around you, something will rise up and attract you, some ensemble of objects, lines and tones. Don't try to use a commercial view-finder, for that has just the opposite effect. It cuts out and isolates. True, your drawing will involve

some elimination, yet it will be less an excerpt from nature's abundance than a summary of its diversity.

When an attractive view catches your eye, ask yourself what the main ingredient is. Hold up your hands horizontally and vertically to frame the picture as you envision it and decide what interests you the most: the bridge, the river or its banks.

Wherever you go, let your eyes search out good composition and make lots of small compositional sketches. Study composition all the time: at the breakfast table, on the street, at the bus stop, in a bunch of flowers! Remember that the main theme does not necessarily occupy the center of your drawing, but you must know what it is, and also what is of secondary importance, where the contrast lies and where the picture begins and ends.

Composition means blending together dynamically placed lines and tones into harmonious unity. Among the many methods of achieving effective composition are symmetry, asymmetry, concentration and diffusion; and the ingredients are horizontal, vertical and oblique directions, curves and masses.

Repeat your exercises in acting-out (see page 24), concentrating on balance and spacing.

Fill many single sheets of stationery with your handwriting. First cover a whole sheet with large script, widely spaced. On other sheets use smaller lettering, tightly spaced, and try many different formats. Study the relationship between the dark written areas and the white margins. Is the writing dominant, or does it seem to balance the white space? Are the margins too even? Are the horizontal white spaces in harmony with the vertical and also with the dark areas?

Here is a fascinating experiment in composition. Decide on a format and then cut out one black square, three horizontal stripes of appropriate size, and one vertical bar. Within the given space, try to arrange the most effective composition. It will be helpful if you can make trial arrangements under a pane of glass. Paste down the final composition.

Composing seascapes is another adventure in cutting out and pasting down. Your ingredients will be the shore in the

foreground, water and sky. How high should the horizon be?
How far should the foreground extend? Try various forms,
some round and some vertical, in the foreground. How large
should they be, and where should they be placed? How much
importance should you give to the foreground? Should it be
the focal point, or simply the framework over which you
view the sea? Try arrangements on paper of various sizes
and shapes.

As an introduction to still-life composition, here is an
edifying exercise. Cut out one large circle and one small
circle, of different shades, and then move them around on a
sheet of white paper. Try to place them in such a way that
the white paper really carries them, and they no longer float
without support. The simplest way, of course, is to place
them close together and then move them slowly apart. Keep
moving them as far as the relationship between them permits
—but not so far that you break the band of tension connect-
ing them and allow the white underground to push up be-
tween them. Try the exercise on various formats to see how
it affects the placing of the circles. Now add a narrow hori-
zontal strip and continue to play the game. These three
elements should make you begin to think of future com-
positions employing a vase, an apple and a table top!

Advancing now to actual objects, arrange a round pot or bowl and an apple on a table in a balanced manner. Enrich this still life with something of similar shape—small objects like grapes, for example; or with a definite contrast such as a slim cylinder or bottle. Draw this composition with chalk, but as always, refrain from simply copying the items one by one. Instead, regard them only as the means with which to give life and vitality to the flat space of your paper.

 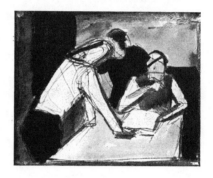

You may go on adding to your drawing non-objective forms and shapes which go beyond what you have set up on the table before you. For instance, add another circular shape —a handle—to your round pot; or enliven the background with stripes or dots or some other actual or invented wallpaper. Then vary your theme with other still-life objects, such as grapes and apples in a round dish.

Thinking strictly in terms of composition, draw several people in a room. Your first problem is which section of the room to choose. Next you must decide which is to be the main figure and where he must be placed. Who is next in order of importance? What are the main directions, and do they correspond or contrast? Where are the weight-giving masses? Work slowly towards the detail. What if you find a hole in your drawing? Suddenly, amazingly, you will find

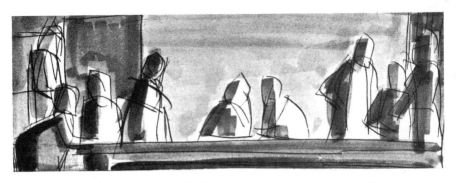

something to fill the hole—a chair, a lamp, a coffee cup, perhaps—something will strike you as being just right!

A well-composed picture frames itself. Step back from your composition and see if yours does. Or is there a diagonal line jutting out beyond the frame? Or is too much weight concentrated in one corner? Does the movement carry the eye out of the picture? What can be done to brighten that corner and keep it from running off the paper? How about introducing horizontal or vertical bars to lock the door on that runaway corner?

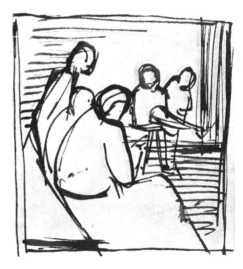

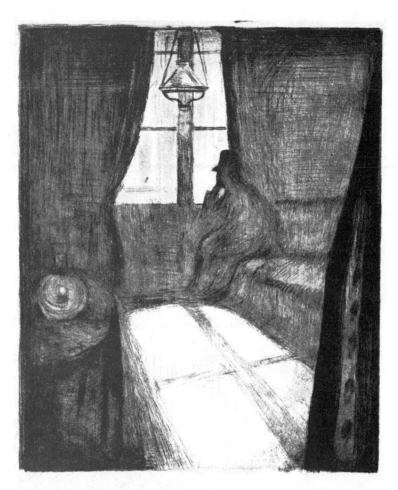

Etching, "Moonlight" by Edvard Munch.

In order to learn and study the relation between negative and positive forms, try the following exercise. Compose a drawing of three or four vases outlined in chalk. Leaving the vases themselves blank, darken the background—the negative form—with a brush and black ink. How does the negative

form compare with the positive? Repeat this exercise by copying a Greek relief, paying careful attention to the rhythm in between spaces.

You will find a further study of masterworks of art most rewarding. Not only Greek reliefs, but also frescoes by Giotto, paintings by Raphael and Marées. First follow their architectural structure with your eyes, then draw it from memory, then look again at the original. Consider the shape and size, the focal point, the main directions, the tonal arrangement, the framework, the subordination of minor but necessary details. With these points in mind, study the compositions throughout this book.

On the next two pages are eight different compositions showing the same motif, the mountain Fuji. All are woodcuts by Hokusai.

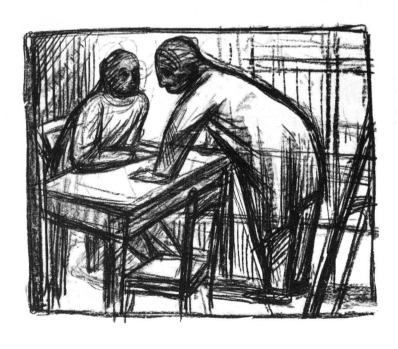

146

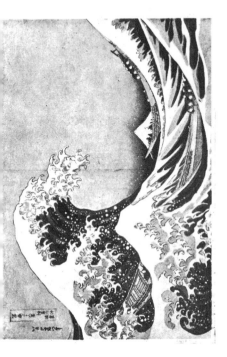

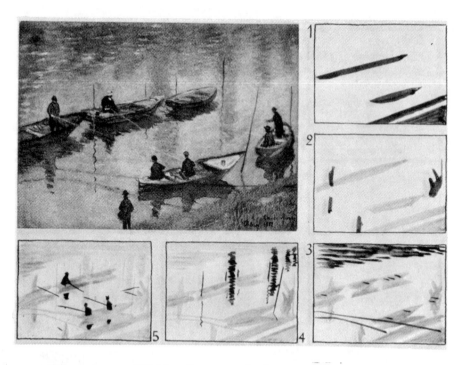

Oil on canvas, "Fishing Boats on the Seine" by Claude Monet.

The painting by Monet demonstrates the elements of composition and construction of a picture especially well because it does not seem to be "composed" at all. Indeed, the view seems so casual as to be almost accidental. How many of the above considerations Monet had in mind when he composed this picture we do not know. We do know, however, how carefully he studied Japanese woodcuts and the works of the old masters in the Louvre.

The theme of his picture is the Seine with its silently flowing, shimmering water. The most important area, around which everything revolves, is the water between the two rows of boats (Illustration 1). The main direction, from lower

left to upper right, is pictorially expressed by the flowing water as it comes from far away and goes on and on. To confine the flow within the limits of the painting, the artist drew the edges into the picture (Illustrations 2 and 3). Next he added vertical accents. The soft reflections of trees along the river bank (the trees, of course, are invisible) and the hard, sharp upright poles in the water pin the motion down and help break up the space (Illustration 4). See how the symmetrical arrangement of the four poles beyond the two upper boats concentrates your attention on the center of the picture; and how the reflection of a tree extended between the two very center sticks, and the two fishermen sit-

Reed pen drawing, "Reeds in the Evening" by the author.

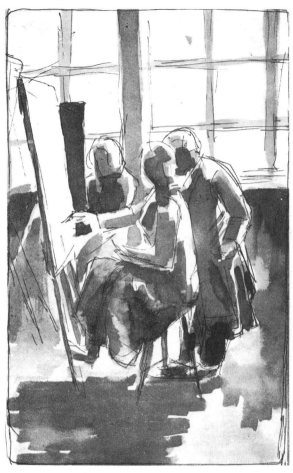

ting just beneath it, anchor the main theme—this spot on the Seine—firmly in the painting and almost exactly in the center. The fishing rods (Illustration 5) also help to lead the eye to the center.

Monet, it is true, probably did not construct his picture with as many calculated thoughts as emerged from the analysis. Instead, his eye instinctively saw this scene as a composition, a pictorial unity, because he had deliberately studied and learned this in earlier years.

THE TEACHINGS OF THE MASTERS

> *How odd it is for men to grow up in the dark,
> like mushrooms, ignoring the generation of
> artists before them. Those who know nothing
> often think that those who know something
> stand in their way. On the contrary, they
> could find guidance from those who know if
> they but sought it.*
>
> —Cézanne

At the age of 86, Ingres copied a painting by Giotto. When asked why he did this he replied, "In order to learn."

Dürer advised, "Copy the work of good artists until your hand has gained freedom."

Today this kind of teaching has few supporters. People feel that genius and inner potential must come forth through personal expression, not through outside influence. But how can you help being influenced? How can you avoid seeing things created by others? Even if you never go inside a museum, you are constantly exposed to art of one kind or another—displays, magazines, illustrations impose themselves upon you all the time. It is what you choose to let take root in you and influence you that matters.

The best place to learn standards, the richest source of knowledge of pictorial unity, is from the masters. The reproductions in this book are only a beginning. Study the originals, if you can, or at least as many good reproductions as possible. Study, compare and train your eyes as a musician

trains his ear. Compare your own work with theirs! Choose your favorite masters. Study them with your eyes and let your hands study them too by copying their drawings. You will find yourself in very good company: Manet copied Titian; Matisse copied Courbet; Liebermann copied Franz Hals; Braque copied Raphael; and long before them, Rembrandt copied Dürer.

EXERCISE IN ANALYSIS

Study the next two pages showing eight treatments of the same theme, drawn by eight students of mine. Try to analyze their differences, their good qualities and their shortcomings. Then see how well you agree with my analysis:

At first glance examples 2 through 6, plus 8, may appear similar in contrast to 1 and 7 because they look more "natural". I would say, however, that numbers 1, 2, 6 and 8 all form one group because they transmit a clear, well-realized picture although they differ in density. Number 1 contains all that is essential in its simple, consistent, precise treatment. Numbers 2, 6 and 8 are not more correct but simply richer and more differentiated.

Examples 3 and 4 are simply poor reproductions of a plantain. Their lines are without rhythm, spontaneity or feeling.

Number 5 is a superficial, careless drawing by a good draughtsman. He actually knows quite well what is important, as is apparent in the rhythms of his composition and the character of his lines.

Numbers 6 and 8 are by the same pupil but quite obviously the intensity of his experience was far greater in 6 than in 8. The lines in 8 are beautiful but inexpressive calligraphy, and the drawing, therefore, remains cool and distant.

1

2

3

4

5

6 ↗

7

8

Number 7 illustrates the first genuine attempt to comprehend the particular forms of the plantain.

Contrary to the first superficial impression, illustrations 1, 2 and 6 are closely related through their creative power and strength, however different their themes may be: number 1 has a certain naïve monumentality; number 2 discloses loving devotion, and number 6 shows decorative generosity.

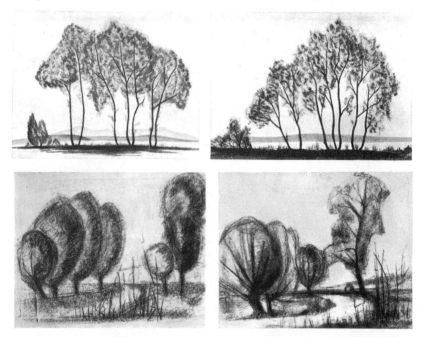

All four of these drawings were made from memory, but with a difference. The artist was dissatisfied with the row of unrelated tree trunks and the uninteresting silhouette of the treetops in the first drawing. He visited the scene once more and studied their rhythm, form and articulation. He then returned home and drew the upper right-hand drawing, in which everything harmonized and "jelled". The two lower pictures tell the same story.

INDEX